ABANDONED
SOUTHERN
MICHIGAN

SKELETONS OF INDUSTRY

BRYCE RICKMAN

AMERICA
THROUGH TIME®
ADDING COLOR TO AMERICAN HISTORY

America Through Time is an imprint of Fonthill Media LLC
www.through-time.com
office@through-time.com

Published by Arcadia Publishing by arrangement with Fonthill Media LLC
For all general information, please contact Arcadia Publishing:
Telephone: 843-853-2070
Fax: 843-853-0044
E-mail: sales@arcadiapublishing.com
For customer service and orders:
Toll-Free 1-888-313-2665

www.arcadiapublishing.com

First published 2020

Copyright © Bryce Rickman 2020

ISBN 978-1-63499-268-8

Typeset in Trade Gothic 10pt on 15pt
Printed and bound in England

CONTENTS

ACKNOWLEDGMENTS

I want to say a big thank you to Breezy and Aaron for being so supportive and joining me on several of my explorations. I also want to thank my family, my friends, and anyone who has ever said they liked a picture that I've taken; hopefully this book will serve as that thanks, because these pictures are for all of you.

With Love, Bryce

INTRODUCTION

A s a person, I'm inspired by many things in life. Music, art, poetry, photography, philosophy, history, space, sound, light, *et cetera, et cetera ad infinitum.* However, four big things aside from my naturally curious mind have served as my impetus and inspiration for engaging in, and documenting, the act of urban exploration.

The first is empathy; I have always enjoyed an engaging story, but something I have come to appreciate more is creating my own stories: dressing the stage of my mind, and letting the characters I create dance through scenes that may have never happened at all. More important than just imagining these miniature dramas is putting myself into the shoes of the characters I have made. What did they do in this space? Who were they? How long did they work in this place? Were they just a visitor for a day? Who are their family and friends? What did they feel? What drew them to this place? All these questions run through my mind the entire time I'm exploring one of the many remains that dot the cities surrounding us. To me, every building I enter is an exercise in empathy. I'm attempting to bring into myself the experiences of countless other people whom I have never met—to experience for a couple of hours what they may have experienced for years of their lives. Yet without the ability to speak with any of them, I am left to speculate within the theatre of the mind.

The second is a respect of nature; growing up in Michigan, I've spent many summer evenings on the shores of our lakes searching for rocks or camping in the vast forests of Northern Michigan— seeing the power of the Great Lakes that reach their fingers inland through tributaries, and whose waves have pulled hundreds of boats to their impressive depths, and admiring the massive sand dunes that cover miles of land and stand hundreds of feet high. To see nature reclaiming the

structures humans built after as little as fifteen or twenty years is awe-inspiring. It's humbling to see how rapid and unrelenting the forces of nature are in the places that we're unable to stave off their assaults. It really undercuts the invincibility that we as humans often carry. The phrase *Igne Natura Renovatur Integra* [through fire nature is reborn whole] serves as a fitting testament to the power of nature to rebound in the face of us building our cities over large swaths of it, and underscores who the winner of that seemingly eternal struggle will one day be.

The third is a desire to have novel experiences. One of my favorite questions is: "Would you rather have good things, or interesting things happen in your life?" Unequivocally, I always choose interesting. If it's something that few people have done, I want to do it. If it's something few people have seen, I want to see it. If it provides a story worth telling, well, count me in. Very few people out of the totality of all humans ever see the inside of or find beauty in the dilapidated, decaying remains of a building. It's something a small portion of the population actively seek out and enjoy, so allow me to share with you a little perspective into the beauty that exists in the withering frames of vacant buildings.

The fourth and final thing is a deep interest in liminal spaces. The definition of a liminal space is a place in transition. To those who may not know the word, you certainly know the feeling. The unease of being in a store after hours, a subway station with no one in it, or a park after dark. These places exist as liminal spaces because your mind has a context for everything it experiences. You know you're only supposed to be in the store during business hours. You know the subway station is supposed to have people queued up and packed like sardines. You know that the park is supposed to be visited and enjoyed during the daytime, where families and their children picnic or play on the swings, or runners are supposed to be training. In a vacant and decaying building, you know that it was once a place of business or of industry or of entertainment. We build buildings for the express purpose of people using them, and when that context is removed, it becomes a place stuck in time. A building with no people is a building without purpose, and it feels wrong. That feeling of unease is a beautiful mystery that never gets old to experience. Perhaps it is that unease which drives people to create graffiti on its walls, to smash its windows, or to try to document it via photography or video. We want that context and understanding and in lieu of a typical context, we create our own. Humans are, if nothing else, tenacious in our fight against entropy.

Of all the inventions of communication to come about, photography is seemingly one of the most efficient at describing experience. Seeing is believing for many people, and as opposed to trying to paint something from memory or recall through thousands of lines constructed deliberately and carefully to attempt to convey to

our senses an experience, photography provides an answer. In the absence of a better description, the old cliché of "A picture is worth a thousand words" will have to suffice. My intention is to capture the experience with as much honesty as I can, but at the same time, also spark that creative storytelling part of your mind by letting you ask all the same questions I do.

I am a relative newcomer within the world of urban exploration. My journey with it, as well as with photography, intersected at once on a whim (as most of my creative ventures do) yet I've always carried a fascination with the things people leave behind, the history of those things, and how once thriving titans of industry can experience their own deaths and subsequent decay as scavengers quickly strip it of its valuable material, other creatures move to inhabit it or intensify the sloughing of its flesh, and eventually the unrelenting march of time and exposure to the elements pulls its bones in on themselves, returning them to nature and to the earth. The cycle of life is not reserved exclusively for the living.

Come along with me on this exercise in empathy, this journey into liminal spaces, this genuinely novel experience from which to gain a new perspective on life, death, rebirth, and time through the lens of destruction, decay, nature, concrete, and steel as we venture into the skeletons of industry.

1

INDUSTRIAL SKELETONS

Industry is defined by the *Merriam-Webster Dictionary* as:

> 1a: manufacturing activity as a whole
> 1b: a distinct group of productive of profit-making enterprises …
> Industry [*https://www.merriam-webster.com/dictionary/industry*]

When prompted with the word industry, I'd wager that most people associate it immediately with billowing clouds pouring from smokestacks made of brick, the whirring and clanging of machinery echoing around cavernous warehouses and factories, as burly men's men in dirty blue coveralls with their soot stained hands and faces labor at rapid paces in a chaotic dance of production lines and catwalks. This almost cartoonish image may be exaggerated, but there was a time only seventy years ago where it was much closer to reality, only starting its steady decline following the end of World War II.

The factory job on an assembly line was once the financial mainstay for large swaths of America's population for many years, and plenty of towns in Southern Michigan laid a lot of the groundwork and held many milestones in America's industrialization, from Henry Ford's first assembly line in Highland Park to the famed Rosie the Riveter, whose likeness was associated with Rose Monroe, a riveter in Ypsilanti's Willow Run B-24 manufacturing plant, who became a symbol for the industrial war effort of America's working women. These milestones unfortunately would not continue to hold purchase.

Following the end of World War II, America's economic and political power were secured and manufacturing jobs were sent on a decline by a multitude of factors,

including but not limited to the end of wartime production efforts, automation, companies finding cheaper labor overseas, racial tensions (notoriously the race riots of 1943 and 1967 in Detroit and the subsequent "white flight" to the suburban Metro Detroit area), and various recessions following the height of America's economic power in the 1970s, 1980s, and more recently, the Great Recession in the late 2000s. All of this culminated in industry in the U.S. taking hard economic hits and living for years in a state of economic famine, from which some were able to recover, but in some cases resulted in others having to close their doors permanently—especially those in the Rust Belt, of which most of Southern Michigan is encapsulated.

This great culling of industry in Southern Michigan has resulted in dozens, if not hundreds, of industrial buildings being left empty for twenty years or more. The most well renowned is the Packard Automotive Plant, which covered a whopping 3.5-million square feet at the height of its use and has had parts remain abandoned for over sixty years. Several of its ancillary buildings have been demolished over the years. It is currently undergoing renovations, but it serves as a monolithic reminder of how these great industrial centers of power can just be left to decay.

However, the community that is urban exploration is an organic being, and the people who occupy it will always find new locations to flock. Now that the Mecca of urban exploration that was the Packard Automotive Plant is being renovated, the pilgrims of decay have found a new sanctuary in Fisher Body Plant No.21, located just two-and-a-half miles southwest of the Packard Plant, which has been abandoned since the 1990s. This relic of the automotive industry, while mostly empty, still contains the tracks that the auto bodies it manufactured would ride along, as well as some shells of machinery. Along the same vein, an honorable mention is the Cadillac Stamping Plant (which also recently started undergoing renovations) located on the east side of the city. It inevitably would succumb to the same fate as its competitors and sister buildings. Regardless of the name, locations like these all represent the larger tragedies on the timeline of industry in the U.S.

When left to fall apart, buildings undergo a rather brutal cycle of decay. If not immediately occupied by another business or outright demolished, one of the first things to happen is metal scrappers will descend upon a place and take anything that isn't bolted down, or that they can carry. Wiring is also stripped right away, for the obvious reason that copper is very valuable. Once the lifeblood of the building has been drained, vandals descend, destroying drywall, shattering windows, and damaging doors and floors. There is also occasional arson, and of course the ever-present graffiti. This vandalism can further incite the rapid decay of a place, because exposing the structure to the elements and inclement weather will immediately and rapidly have an effect on the structural integrity of a place as well as have a

compounding effect whereby the initial exposure results in the structure being rapidly weakened and allowing more exposure to occur. Typically, by the time those of us interested in documenting these places get there, there isn't much left, especially if it's a largely wooden structure. However, larger industrial buildings tend to stick around a bit longer, even if it's just the concrete and I-beams, as these take longer to structurally weaken enough to truly fall apart.

Unlike the great skeletal remains of the automotive industry in Detroit, the smaller industrial locations I've visited have, for the most part, been spared the same advanced levels of decay. For example, the Crown Vantage Paper Mill in Parchment, MI (about a mile North of Kalamazoo), is surprisingly untouched aside from the collapse of the wooden structures, broken windows, and graffiti. This is despite the fact it has been abandoned since the 1990s. It sits on a sprawling seventy-three-acre lot. There's still a ton of metal and piping, and a massive roller from their milling; moreover, a lot of the glass is still intact. Another example is a factory in Bay City (a couple miles North of Saginaw) which has been abandoned since at least 1997. It is also widely untouched, partially due to many of the windows being boarded up on the outside, as well as having a pretty well maintained exterior.

In my personal experience, I feel an intense wonder at the sight of these massive factories. The feeling of scale is really exemplified when you're walking through the winding corridors and cavernous warehouses, hearing nothing but the echoes bouncing around an entire building with the sound of your footsteps. It makes you feel so small, and really makes you wonder about how loud this place must have been when it was full of machinery that produced hundreds of thousands, if not millions, of products a year, day in and day out. It also lets you marvel at the ingenuity of human beings and our ability to create these gargantuan structures, let alone build them to last. It also makes you respect the power of nature so much more to see these enormous long standing structures with vines winding through the bricks, moss covering the floors, and trees beginning to sprout in the one spot of sunlight they can reach while surrounded by the countless tons of concrete and steel.

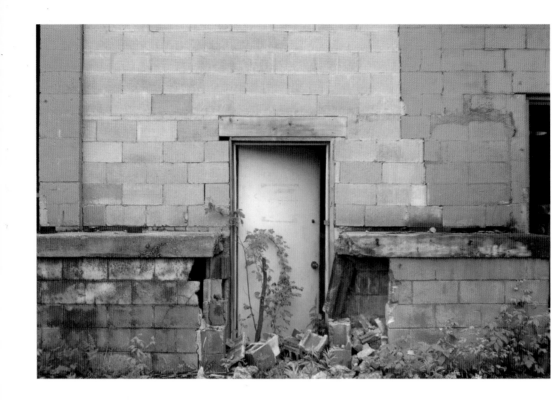

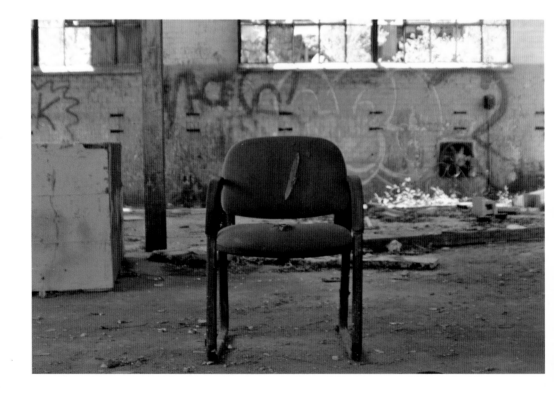

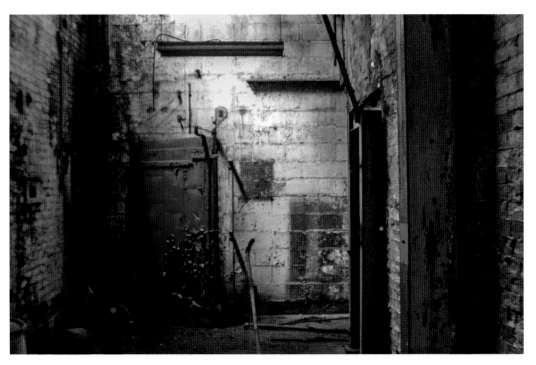

The Red Door. This was one of the first pictures I took that I really felt something from. It captures the ethereal, surreal, dreamlike sense of unease that comes with urban exploration. In my opinion, it really captures the sensation of being in a liminal space.

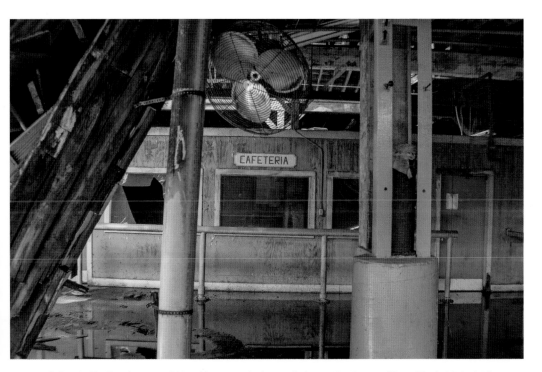

Cafeteria. Finding these small bits of intense color is a really interesting juxtaposition with what is typically a very grey and dreary place. This one, again, captures that sense of being stuck in time.

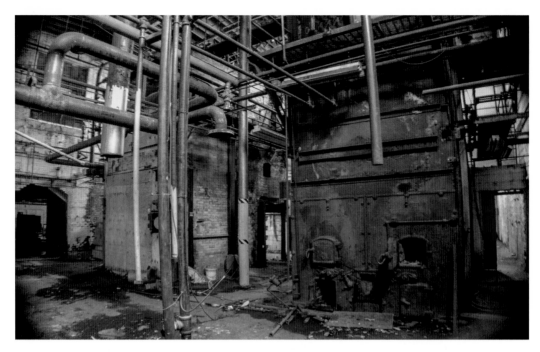

The Furnace. Steam works and furnaces are always so fascinating to me. The sheer space that they occupy in a building, along with knowing that they served a purpose in either powering part of a building or heating it is always interesting as well. You can really sense their age in this photo by the rusted exterior of the one on the right and the brick facade on the one on the left.

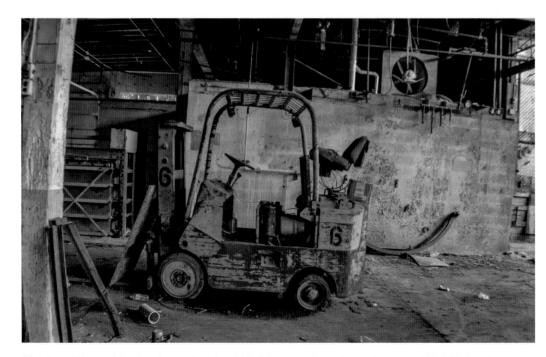

High-Low. Older models of equipment in industrial buildings are always interesting to see. This high-low, for example, is at least twenty to thirty years old, and to see it sitting untouched really reinforces that idea that this place is stuck in time.

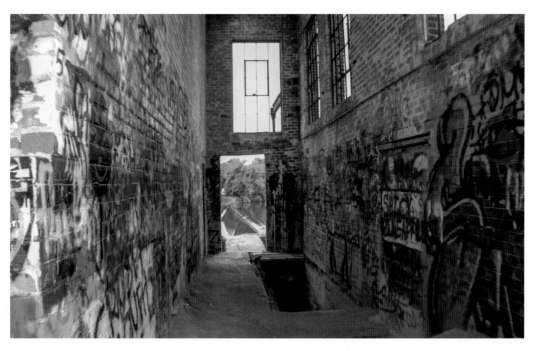

Dam Side. This picture is facing out towards the dam on the Huron River from the generator building that once supplied the Peninsular Paper Company mill of Ypsilanti, MI, with energy.

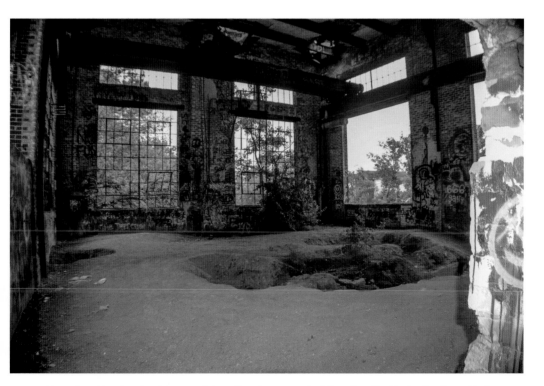

Tunneling. After the abandonment of the mill and generator building, they filled in the first floor with dirt, most likely in an attempt to prevent people from vandalizing the property. However, people are tenacious and have slowly been digging out parts of it, most likely in hopes of accessing the lower level of the building.

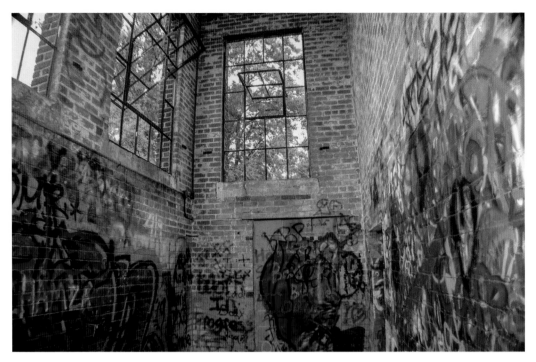

Graffiti. The walls of this building, both inside and out, are absolutely covered in graffiti, some of it good, most of it bad. I can only begin to imagine what this place might have looked like in its heyday.

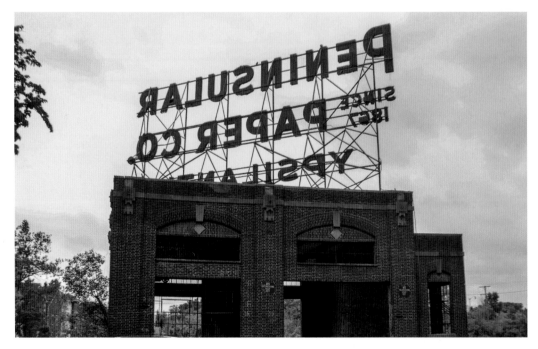

Peninsular Paper Co. The old signage of the mill still sits on top of the generator building, although the mill itself has been gone since 2004, but it carries with it a storied history stretching all the way back to 1867. In 2018, it was voted to have the generator building and dam demolished. It's sad to see such a well-known landmark of that town brought to the chopping block.

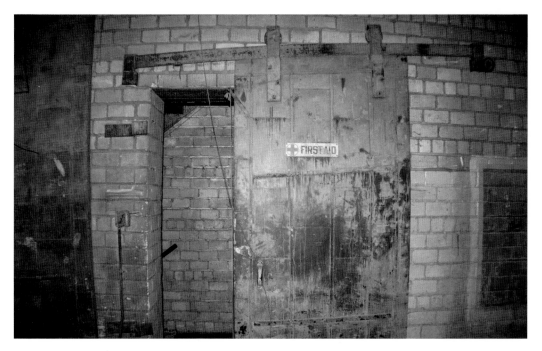

First Aid. This sliding green door leads to the medical bay of what I can only gather to be an abandoned peg board factory. More than anything, it's just a super cool door. I've seen sliding doors of a similar style but much larger. I had never seen one for a single door.

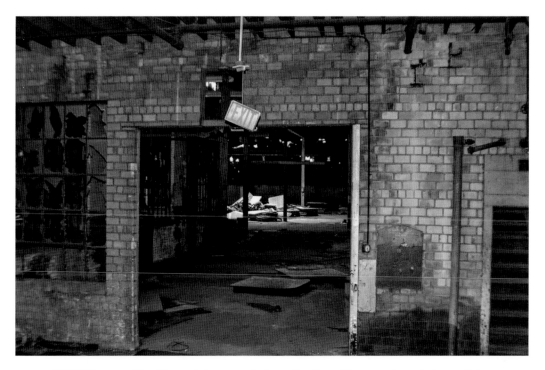

EXIT. I think I took this picture out of a moment of empathy. To see this sad broken exit sign barely hanging on, debris littering the ground behind it, really moved me to think of the workers here. Was this the last thing that caught their eye before they left on their last day? An exit. The way out.

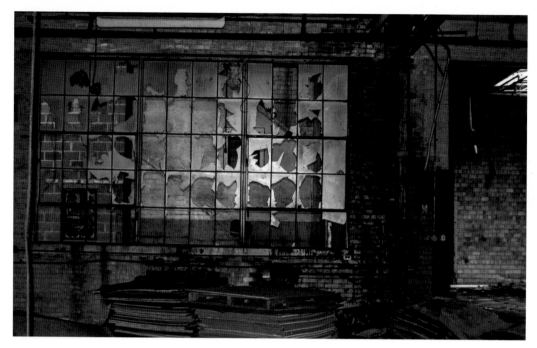

The Rot. It's super fascinating to see walls of windows like this on an interior wall. As with most windows in these locations, they're smashed to bits. In front of them sits a pile of sopping wet (and awful smelling) peg board, left to rot along with the rest of the building.

Yellow Wall. Again, a pop of color in a place that is so dreary is always a welcome sight. I love this little piece of corrugated metal wall. It's adds immense vibrance.

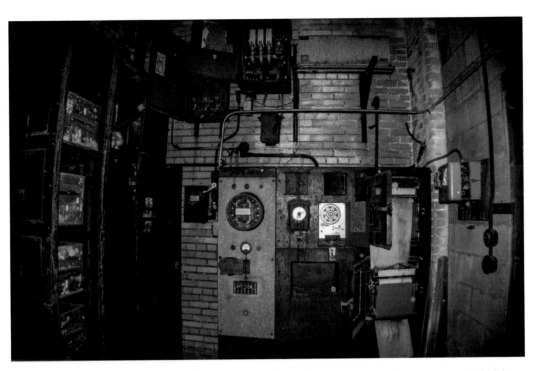

Readout. I often don't know what the machinery in these places are for, and this is no exception. I don't know what these gauges read, but it's super interesting to look at.

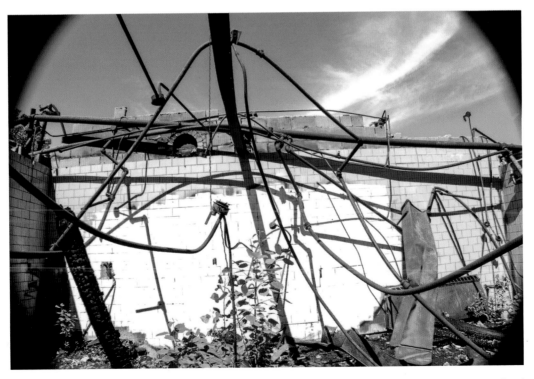

Trip-Wire. The burned remains of one of several buildings at the Crown Vantage Paper Mill left this warped and twisted metal dangling everywhere.

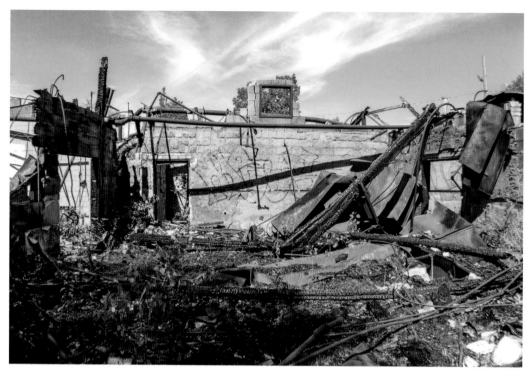

Frame. I love the little square window or vent hole top and center. It reminds me of a church steeple.

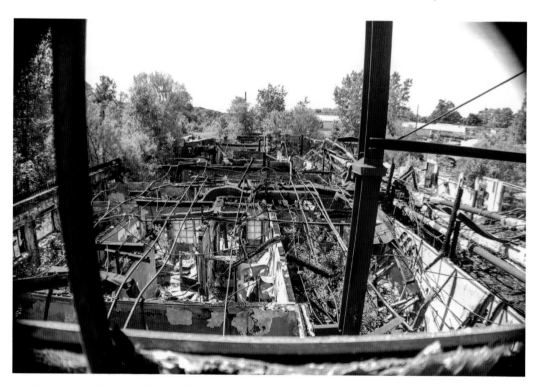

The Skeletal Maze. The burned-out building from above. You can see the layout of the building and only the twisted pipes remain above it.

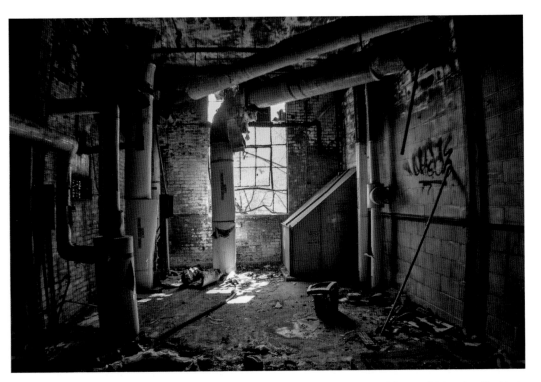

Ghosts. Light is something I always find fascinating in these places, because of the way it interacts with objects and the shadows it casts. This picture captures that ethereal feeling well.

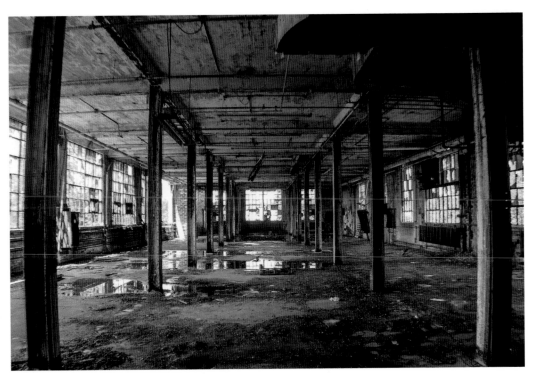

Rib Cage. I love the light in here and how the supports frame the room beautifully.

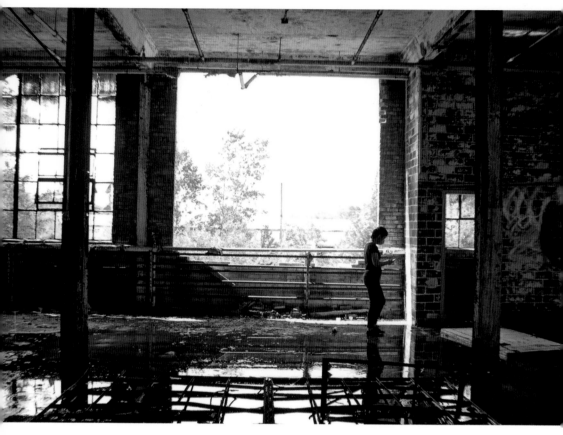

Light. This massive hole in the wall where a window once sat let in so much light and added such a sense of warmth to the room. My friend Breezy for scale.

Opposite: Stairway to Nowhere. This was the only staircase that led further up, but was broken halfway unfortunately.

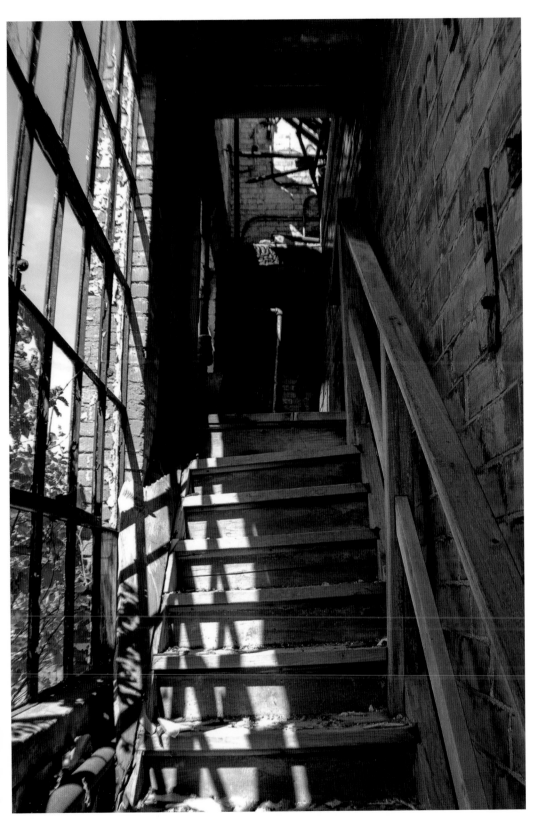

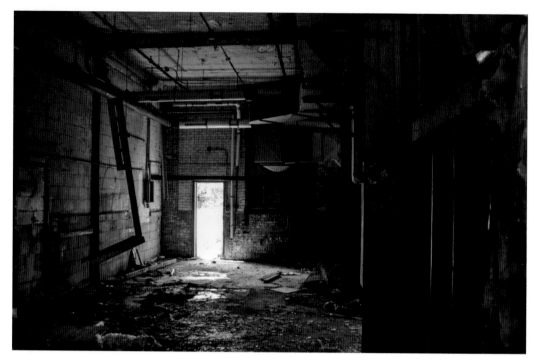

A Way Out. The story this picture tells is so neat to think about. Is it an allegory of light fending off darkness? Is it a way out? A way in? It's all up to you.

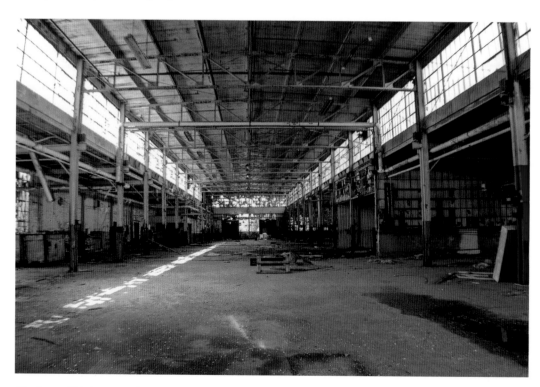

Warehouse. This huge warehouse was at one point probably used for storing equipment and paper, but now sits empty.

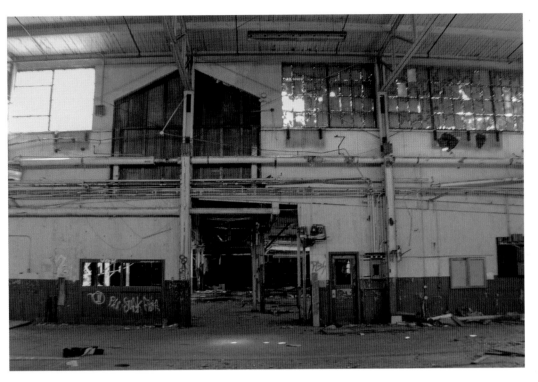

Balance.

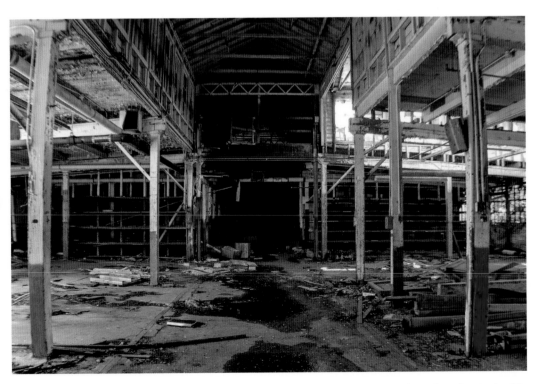

Into The Dark. The structure and contrast between light and dark is really striking here. As well as having little bits of color that really pop.

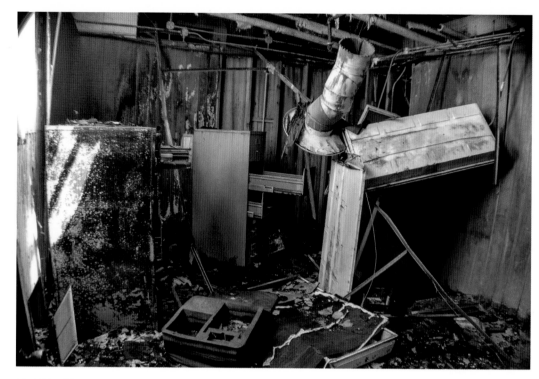

Filed. It's wild to see how much wear parts of these buildings have. These filing cabinets have moss growing on them and the drop ceiling has totally collapsed onto them.

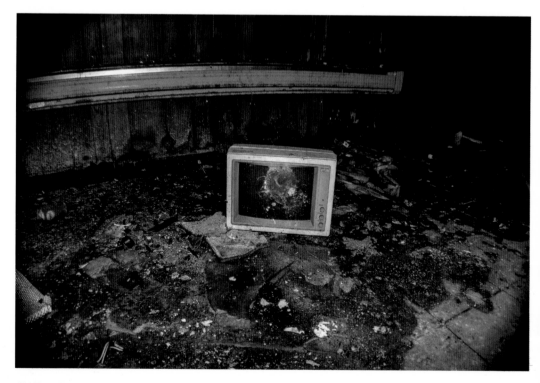

Old Tech. This old computer monitor was just sitting in the hall. I wonder if it still works.

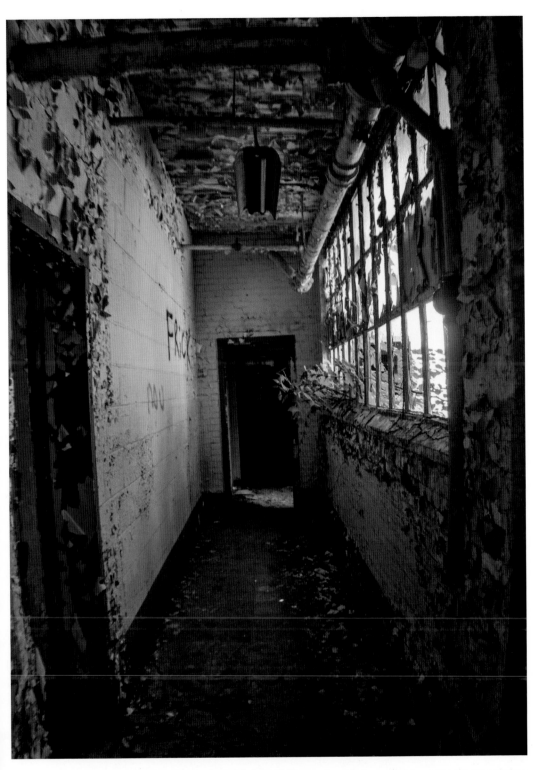

Reaching Through. Paint peeling is absolutely beautiful to me. It reminds me of old renaissance-era paintings beginning to crack. Seeing nature reclaim places is also beautiful to me, like our little friend reaching through the window.

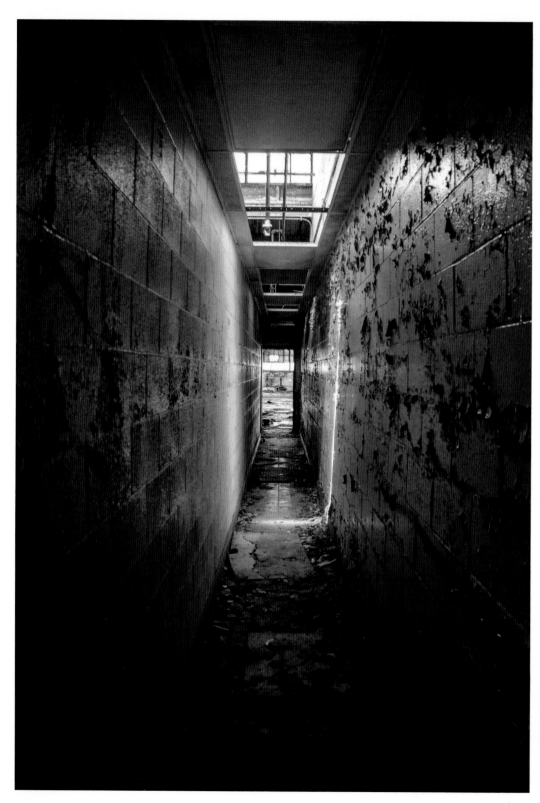

Light Line.

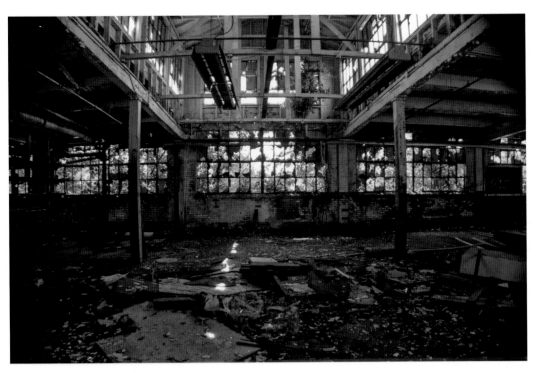

Greenery. The contrast of the green from the plants and the white-grey of the bricks is really powerful and shows how close nature can be to overwhelming a place.

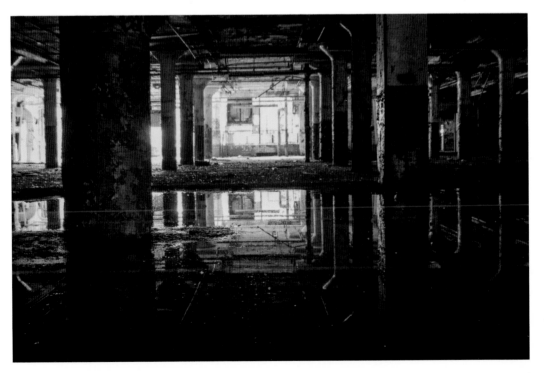

Puddle Garage. Over half of the massive parking garage had standing water. It's interesting when the chaos of nature helps showcase the order that man creates.

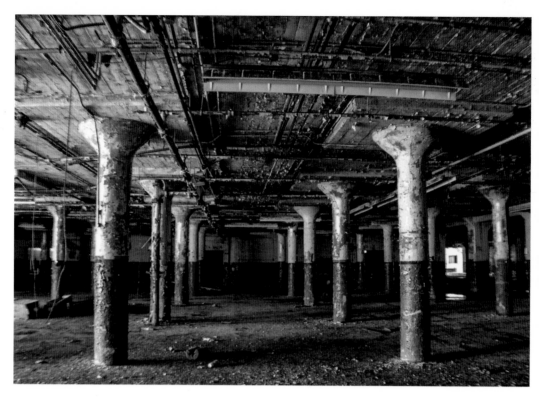

Peel. More gorgeous paint peeling on every surface of the place.

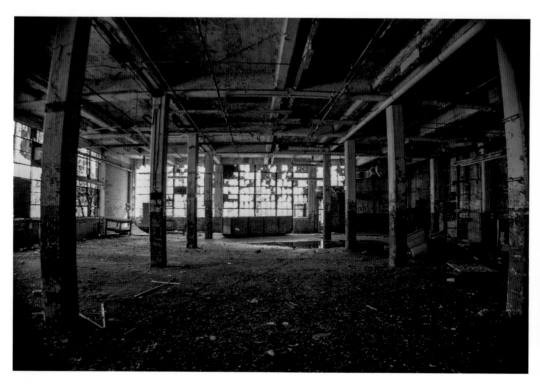

Untitled.

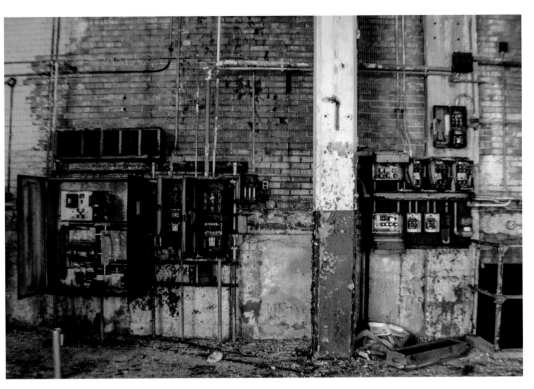

Circuits. Again, I'm not 100% sure what any of this did or monitored, but it's amazing to look at.

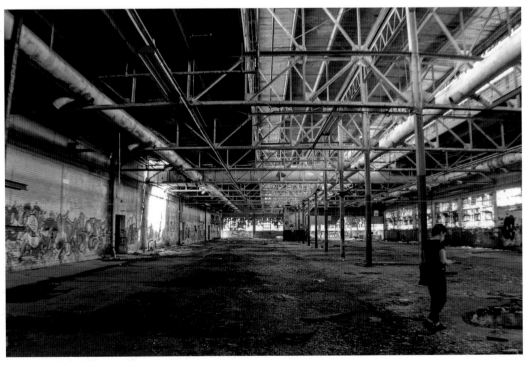

Storage. This is a small part of an absolutely massive storage space that once held huge rolls of paper after they were milled.

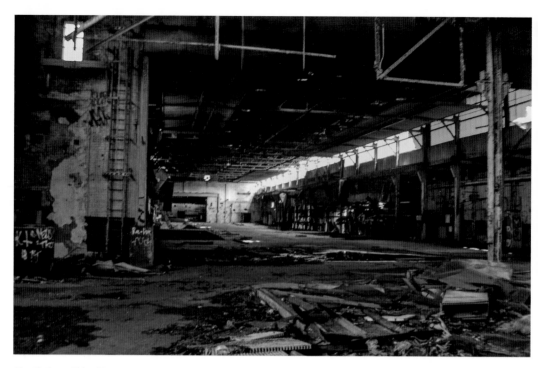

Two Paths to Take. This just shows a section of the gargantuan main building of the mill. The walls were once lined with mill equipment with sheets of paper flying along their rollers. That ladder goes up to part of the roof.

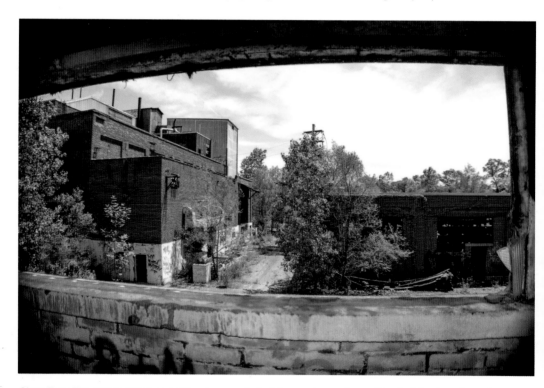

Ghost Town. This picture shows part of the steam works building, and a smaller ancillary building from the main part of the mill.

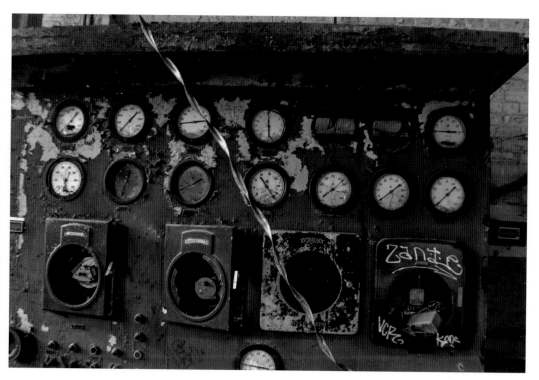

Gauges. These gauges were in the steam works and probably monitored pressure and a dozen other things.

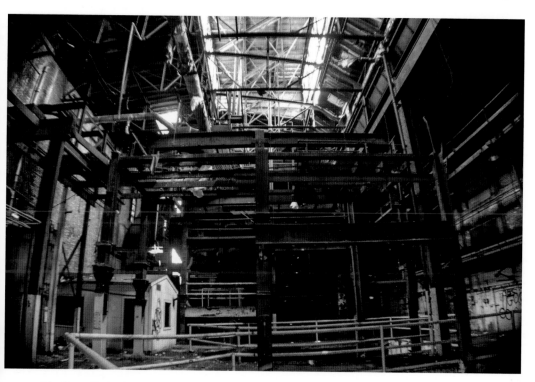

The Steam Works. This is a massive building with a mess of catwalks and pipes that once carried the power that was the lifeblood of this sprawling seventy-three-acre property.

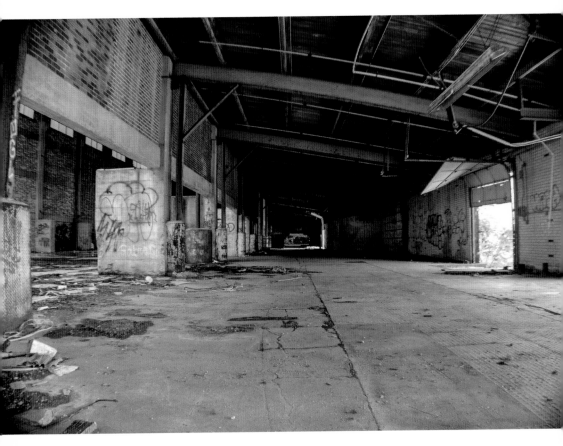

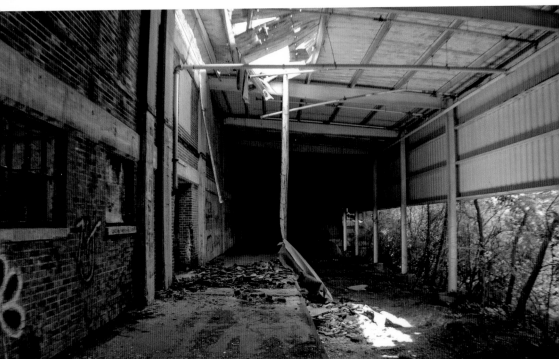

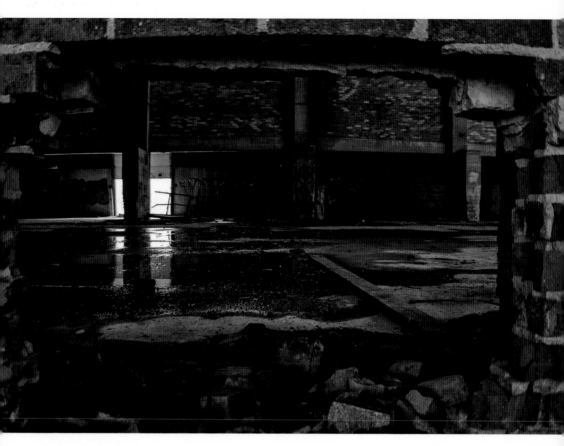

Peek-A-Boo. Finding little holes in walls like this gives the experience a much more fun perspective from which to view things.

Opposite above: Warehouse II. This is a section of a much more massive warehouse, potentially where the raw materials were brought in and stored before being milled.

Opposite below: It Came From The Sky. I thought the light coming through this hole in the roof was absolutely beautiful. Hopefully, no one was harmed in its creation.

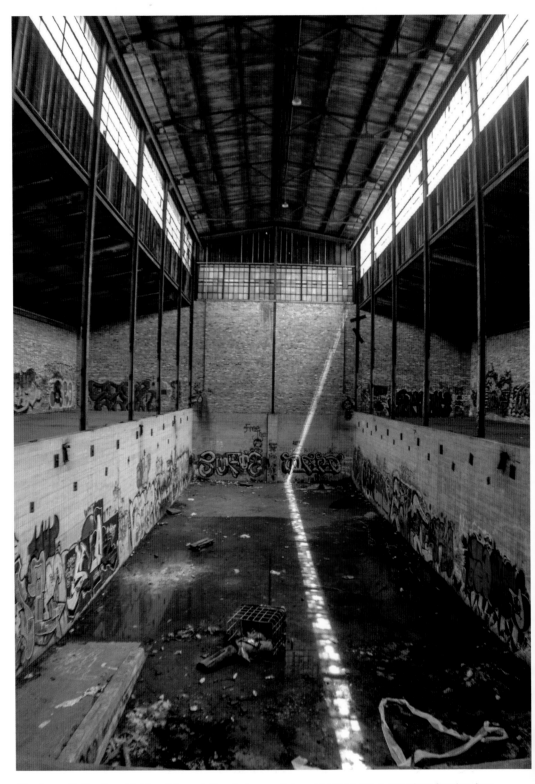

Warehouse III. The line of light cast through the windows and down into the basin is one of my favorites from this location. The size of this place is massive.

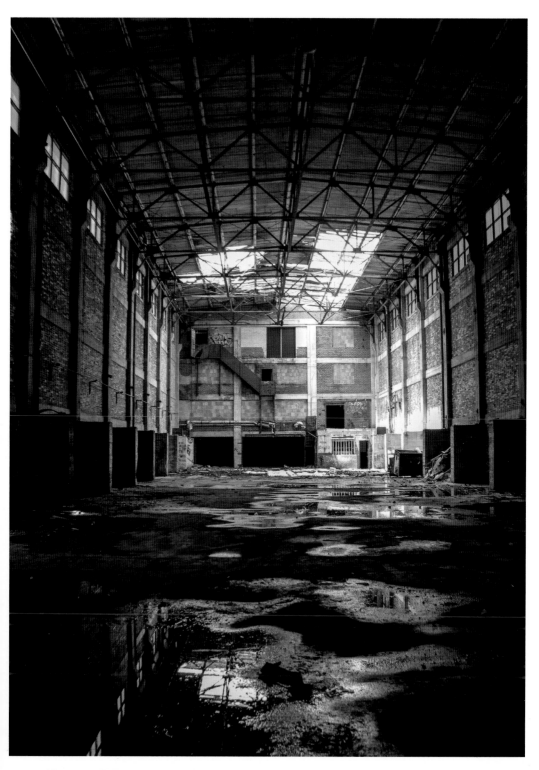

Warehouse IV. This is one of my favorite pictures I have ever taken. The size of the building. The colors. The contrast of dark and light. It's so impactful and humbling to look at. It wouldn't have been the same if the roof were still intact.

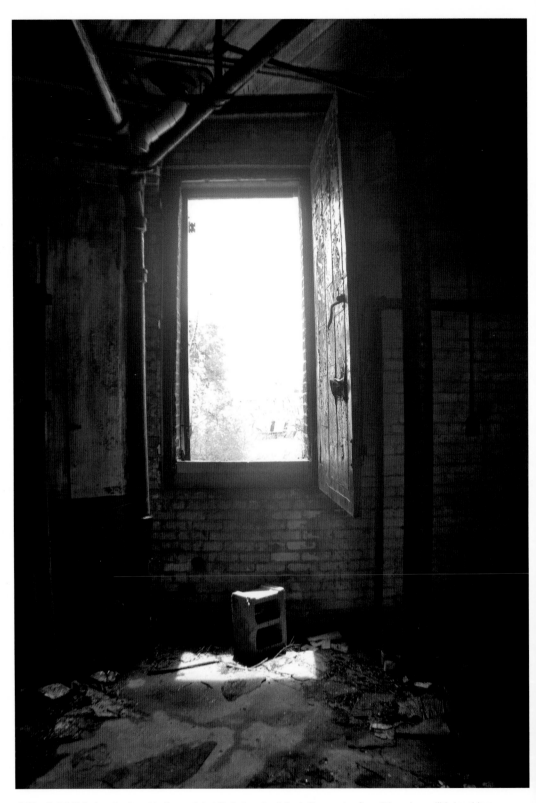

A Way Out II. This door leads out to the roof, but that almost spiritual vibe coming from it is so incredibly inspiring.

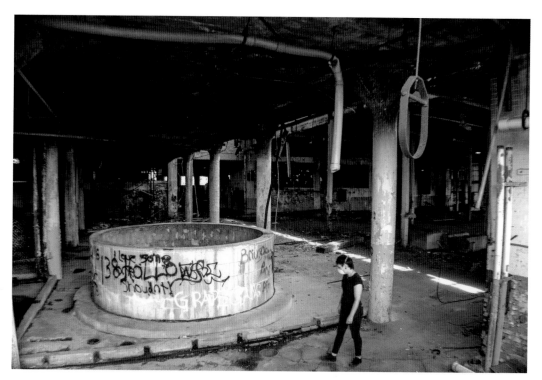

Basin. That basin goes down probably ten feet and it's about eight feet in diameter. I believe they might have been used for washing the recycled paper, although I'm not totally sure on that.

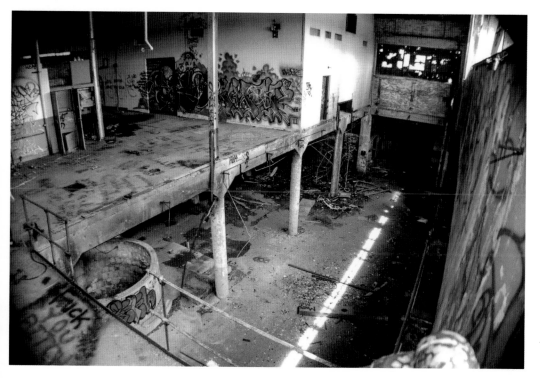

Stripped. This just really shows how much empty space there is here and how unsafe these places can be.

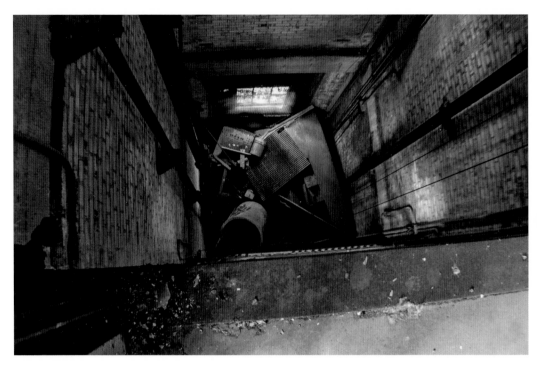

Shaft. The light passing through the grate in the window adds something ethereal to this picture. But also, it's a long way down.

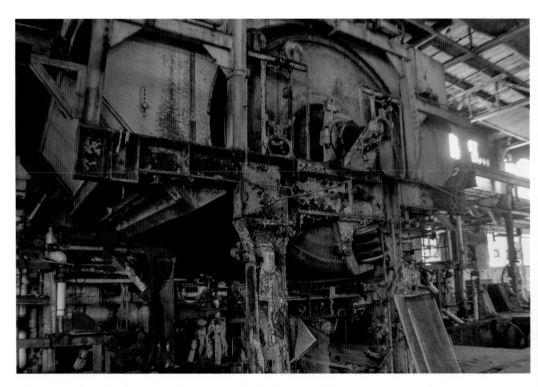

Rolling. This roller is the size of two sedans put wheel to wheel. It's incredibly large. The amount of power needed to get this thing going must have been crazy.

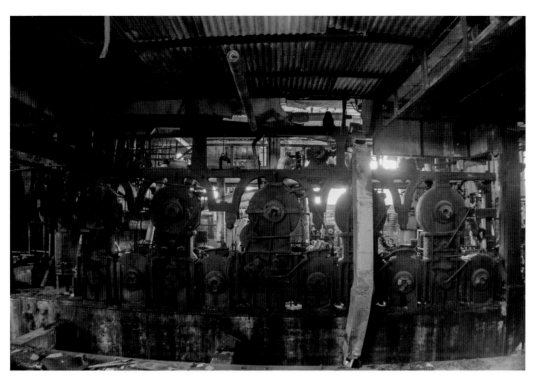

Shells. I assume sets of rollers sat in these sockets at some point, but I don't know for sure.

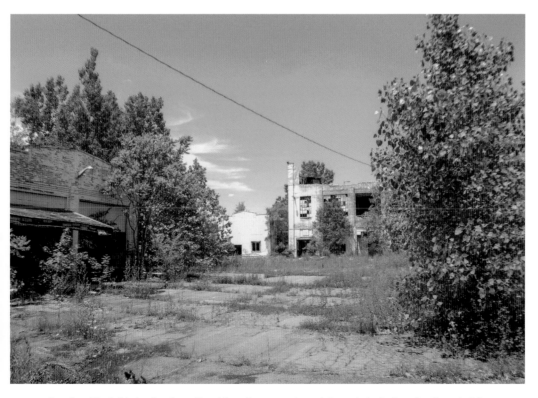

Goodbye. I took this leaving the mill and it really conveys how static and slowly decaying these buildings are.

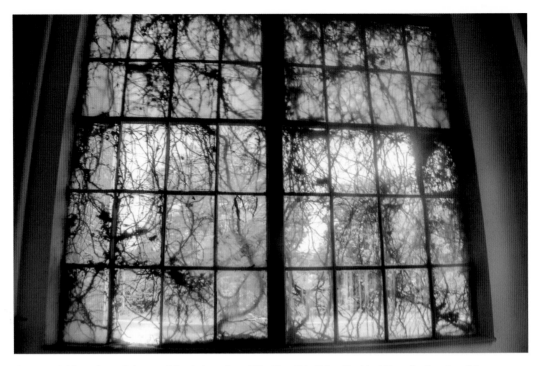

Overgrowth. The color and vines on this window of an old textile mill in Eaton Rapids, MI, really gives the picture a dreamlike feeling.

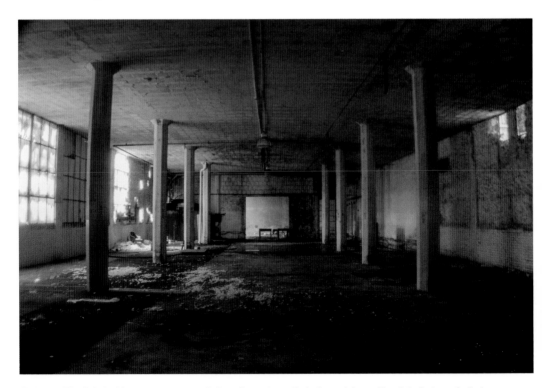

Ballroom. The light in this room was very soft. It again captures that ethereal dreamlike state that you feel when exploring an abandoned building. It feels almost like a dance hall.

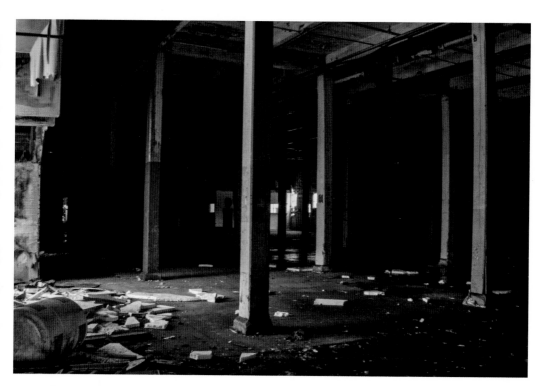

Pillars.

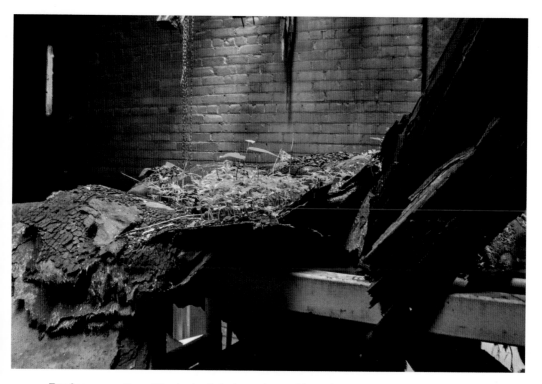

Tiny Conquerors. These little shoots of plants growing on this section of collapsed roof show that no matter how small, nature will find its way back into power.

Shadow.

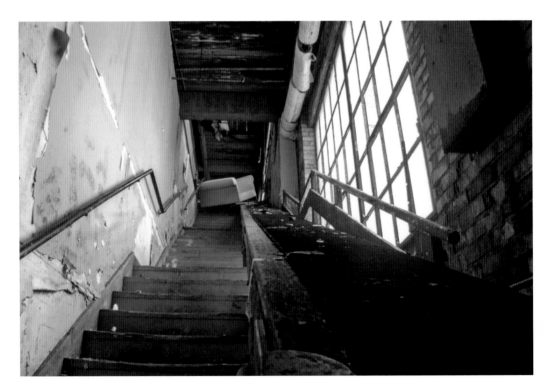

Conveyance. I thought it was super weird and cool that this conveyer belt was on these stairs. It just seemed an odd place for them to be.

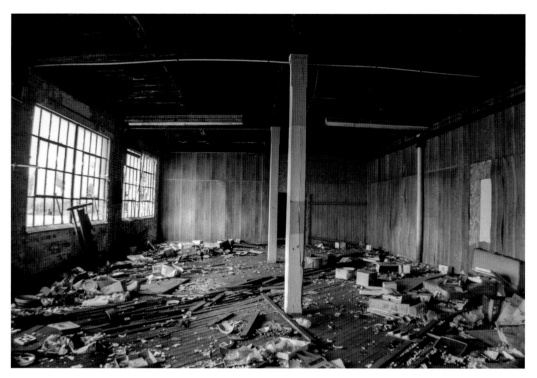

China. This room was filled with smashed plates and cups. Kind of sad in a way.

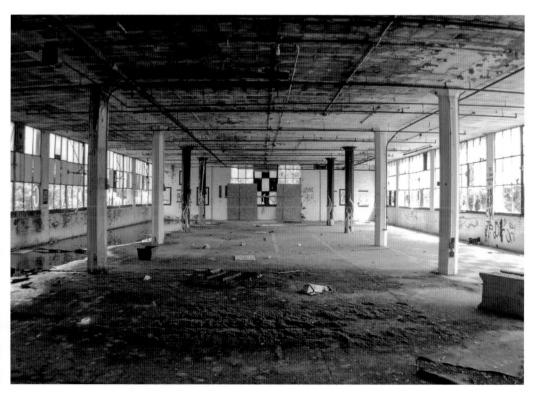

Carpet. It is always fascinating to see moss growing in a building, especially in the center of a room.

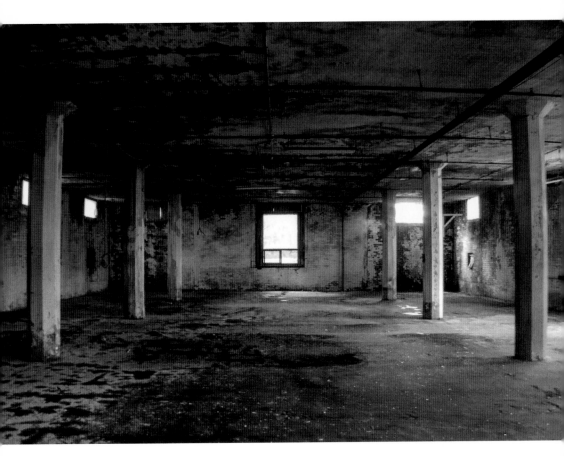

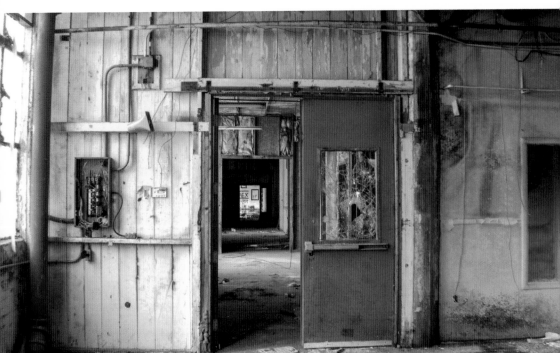

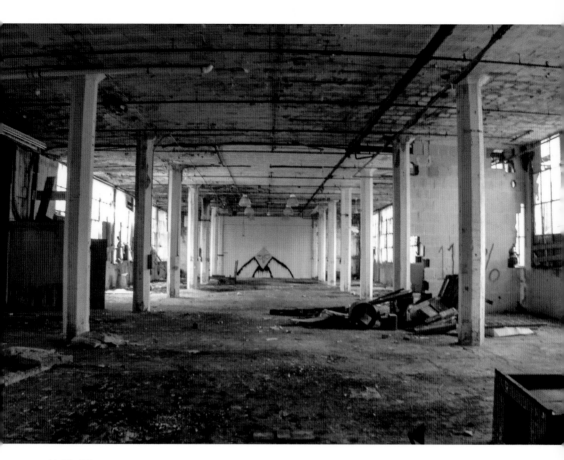

Untitled II.

Opposite above: Cold. I think the juxtaposition of the cold hard cement and the little patches of moss is really interesting.

Opposite below: Squares.

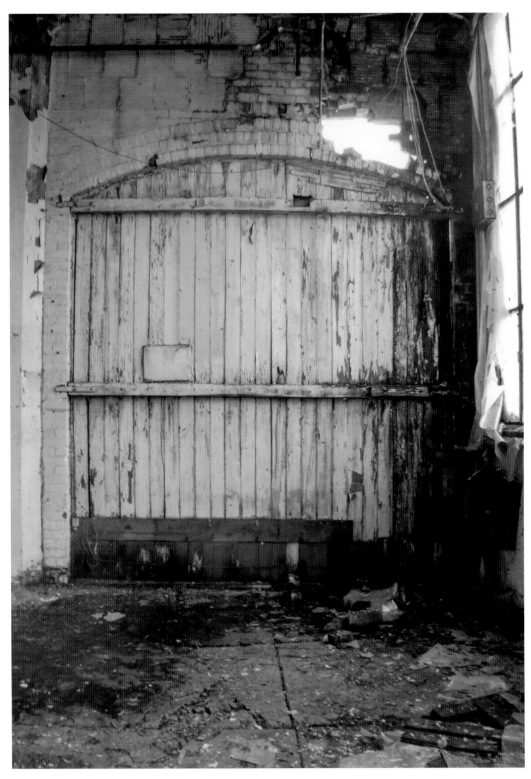

Old Door. This place had a lot of really cool old stuff and this door leading outside was no different. It's very calming in a way.

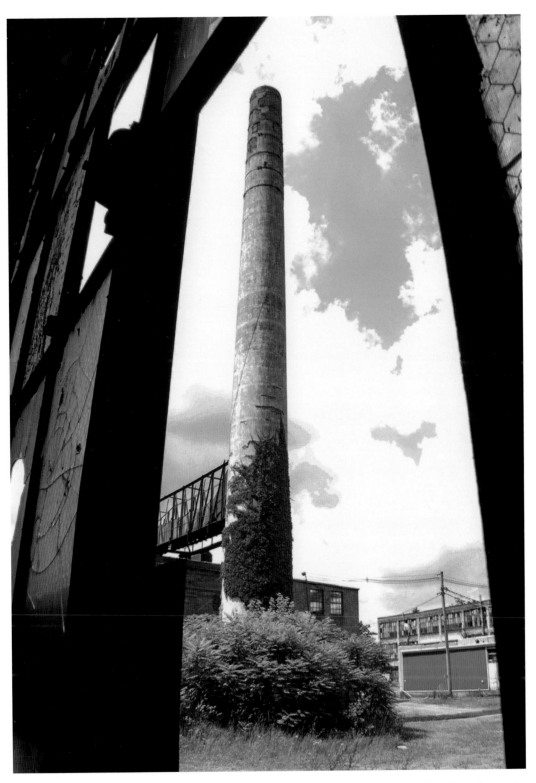

Smokestack. This huge smokestack was in the center of the mill complex. Can you imagine seeing smoke billowing out of it?

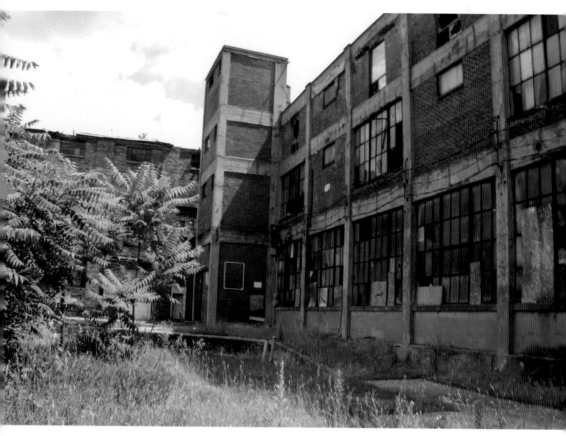

Exterior.

Opposite: Shattered. More broken dishes littering a staircase.

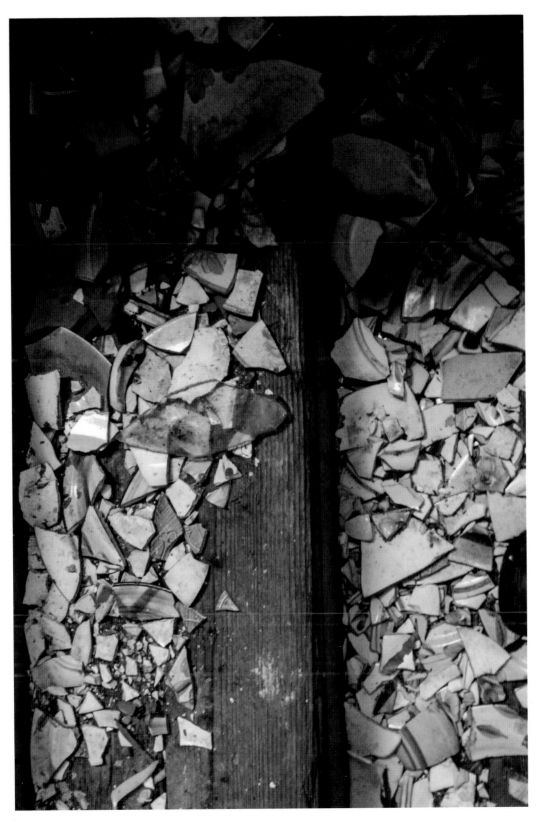

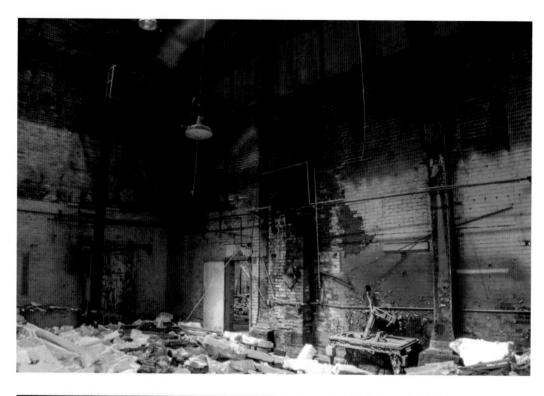

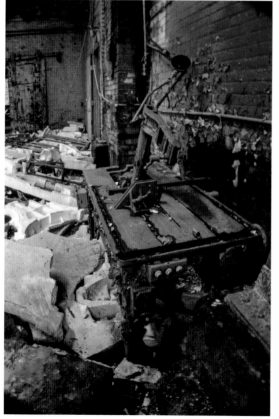

Above: Red Brick, Green Brick. This room was filled with shattered glass from tube TVs. The color is beautiful on that far wall.

Left: Old Tech II. I don't know what this machine is for, but it's crazy to see how much it's rusted.

Opposite: Stairway to Nowhere II. This stairway goes up to the next floor which is conveniently now on the first floor.

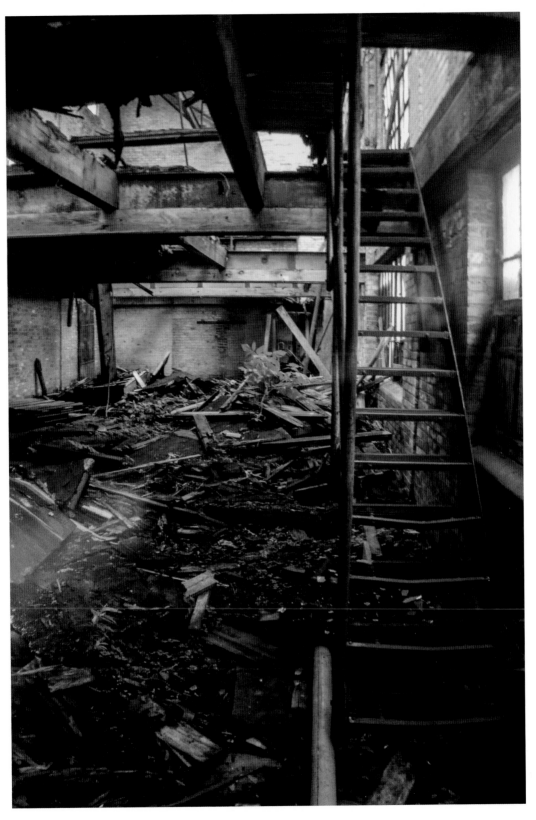

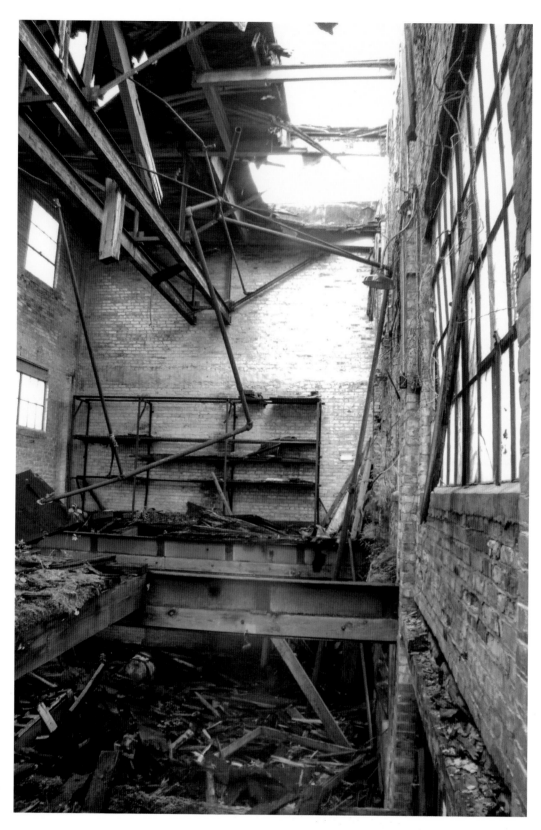

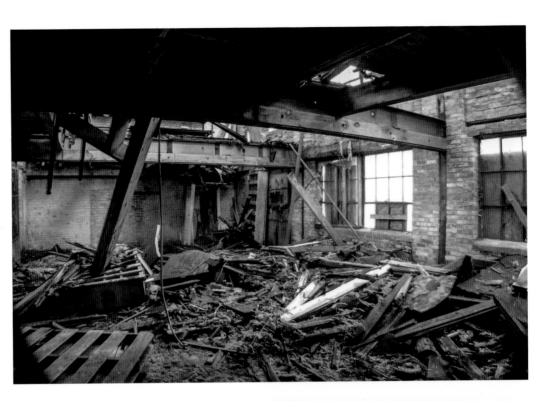

Above: Fallen In. This section of the building is heavily damaged and most of it is collapsed. There's also a ton of plant life here.

Right: Railroad. I believe this once held a track, but the track is gone now and the only things left are the wooden beams and a ten-foot drop.

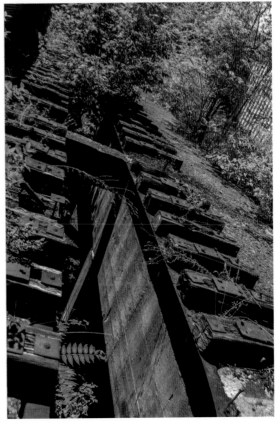

Opposite: Told You So.

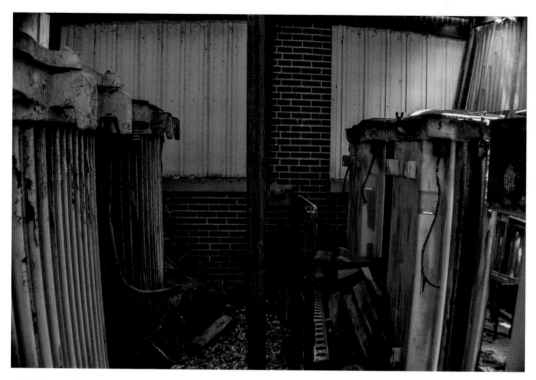

High Voltage. Some large transformers or something to that extent.

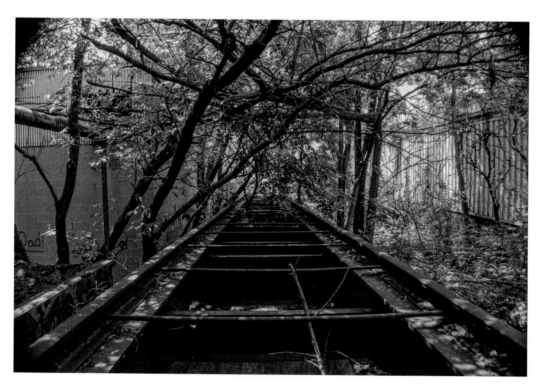

Overgrowth II. This is a continuation of that track, except that the rails are still present here. It's heavily overgrown and doesn't go anywhere now.

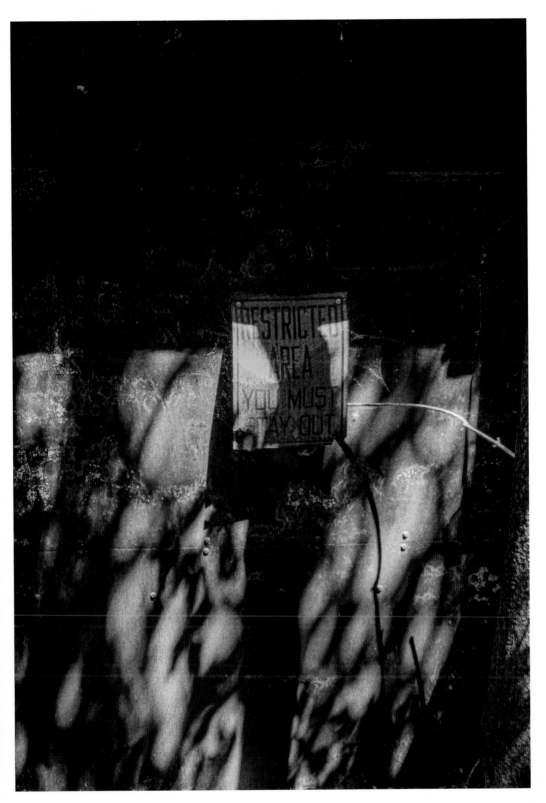

Restricted Area.

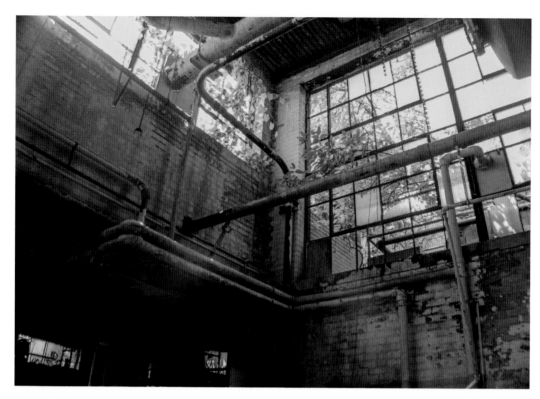

Reaching Through II.

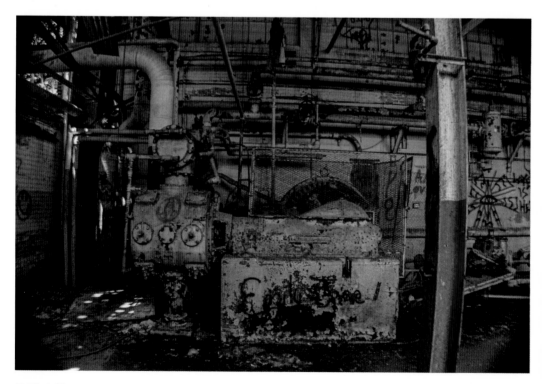

Old Tech III.

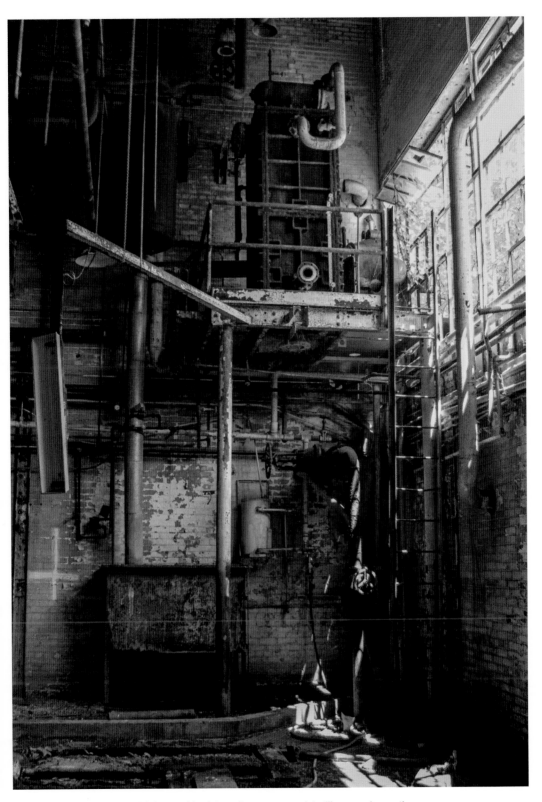

Monolith. I love the lighting on this picture. It conveys a quiet stillness and warmth.

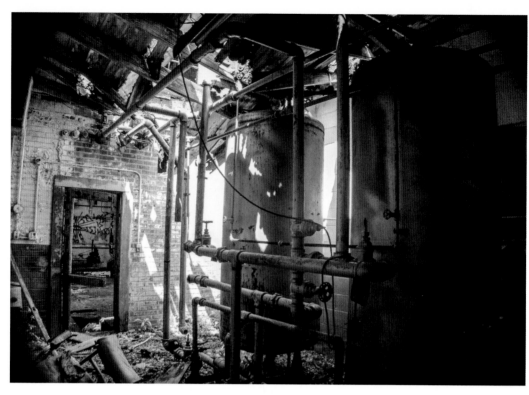

Boilers. There was absolute gorgeous lighting in this entire building in Bay City, MI.

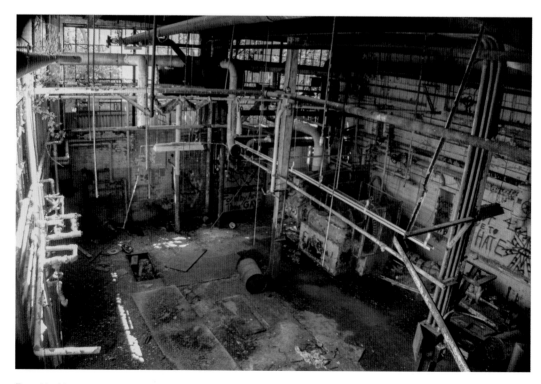

From Up Above.

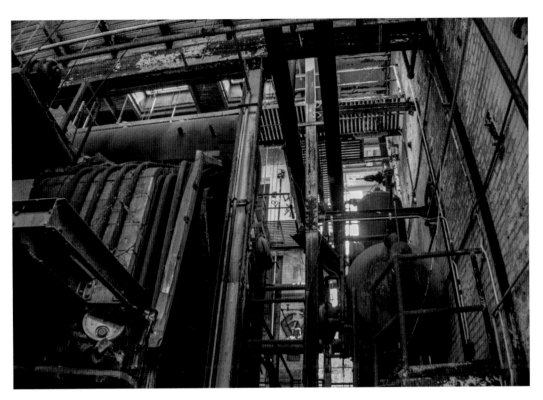

A-maze-ing. There are so many different little paths in places like this, it's astonishing that it'd be built that way.

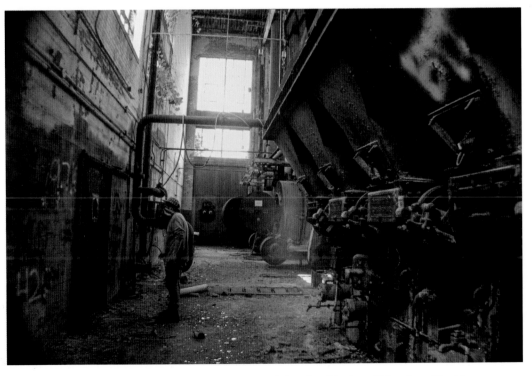

The Steam Works II. Different furnaces and a mess of pipes line this place. Pictured, my friend Aaron.

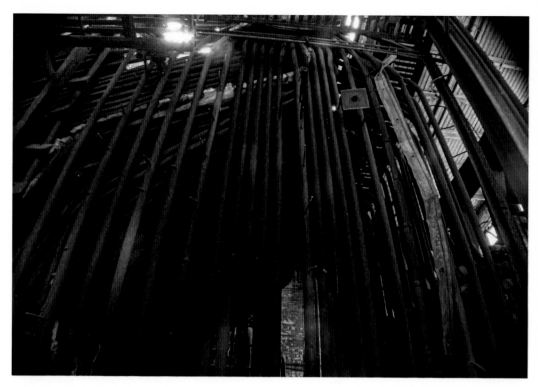

Playing The Pipes. This is an absolute mess of pipes. How can anyone understand how this works?

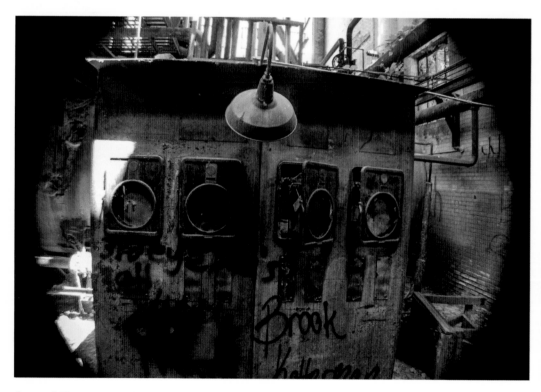

Gauges II. More gauges probably for monitoring pressure.

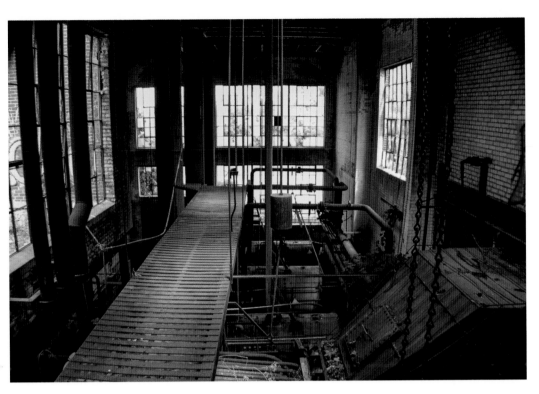

Catwalk.

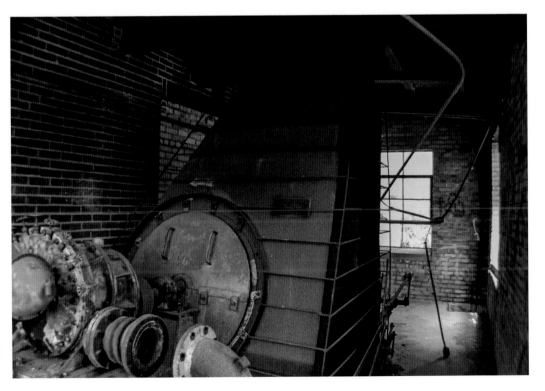

Old Tech IV.

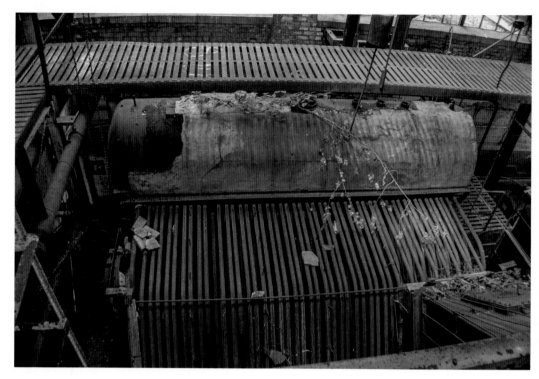

Playing The Pipes II.

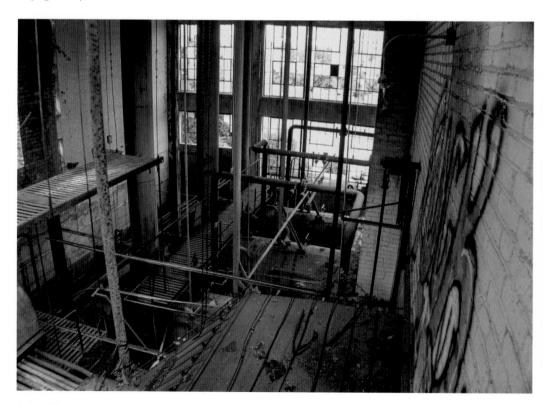

Catwalk II.

Hot Stuff. I think these were part of the furnace system for the steam power.

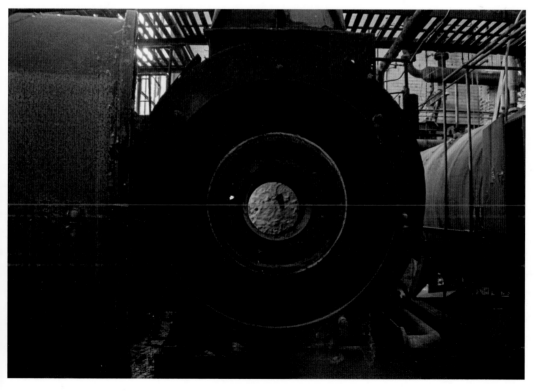

Old Tech V.

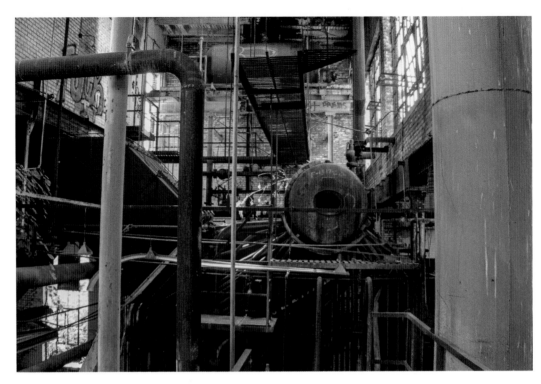

Playing The Pipes III.

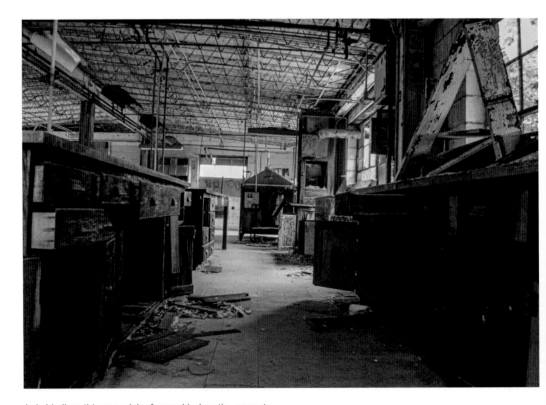

Lab. I believe this was a lab of some kind on the property.

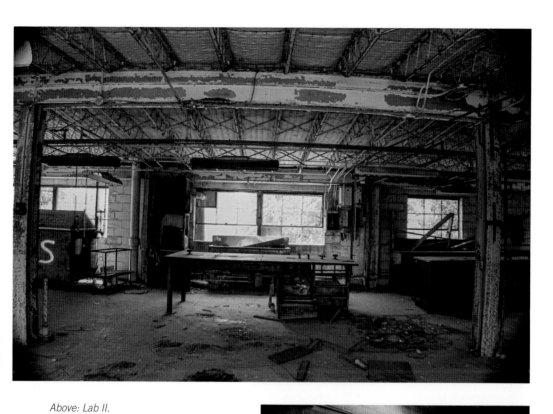

Above: Lab II.

Right: Light Line II.

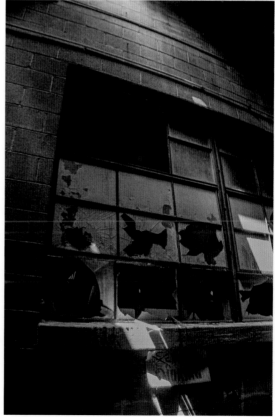

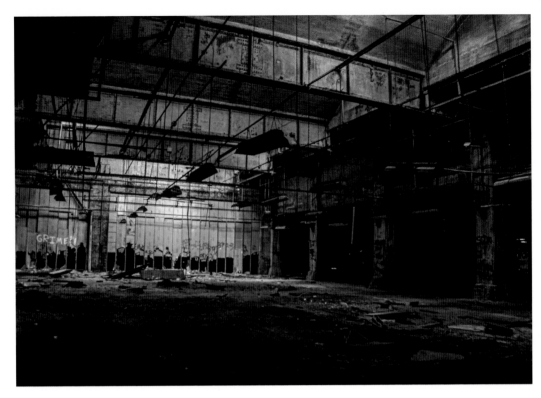

Rows. The hanging rows of fluorescent lighting is intriguing and haunting.

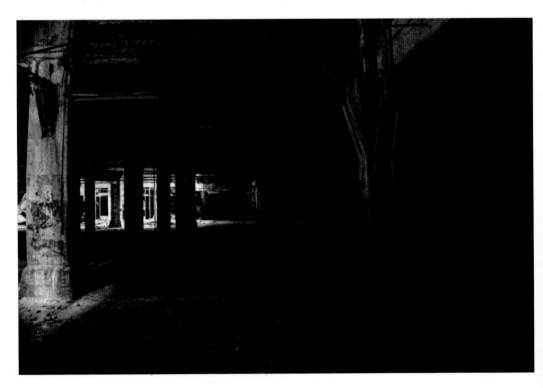

Into The Dark II.

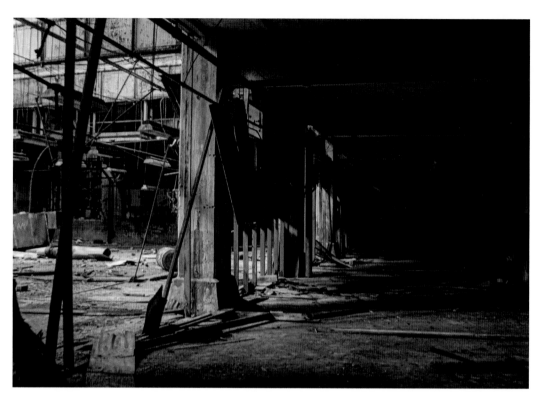

Untitled II.

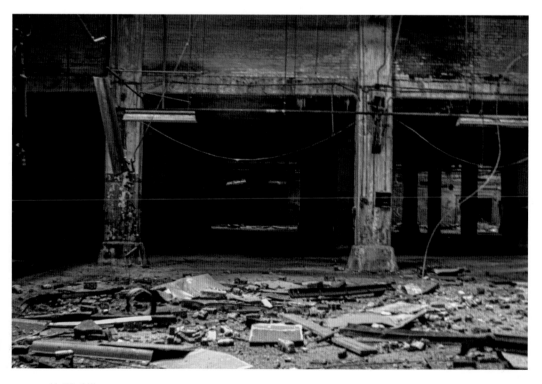

Untitled III.

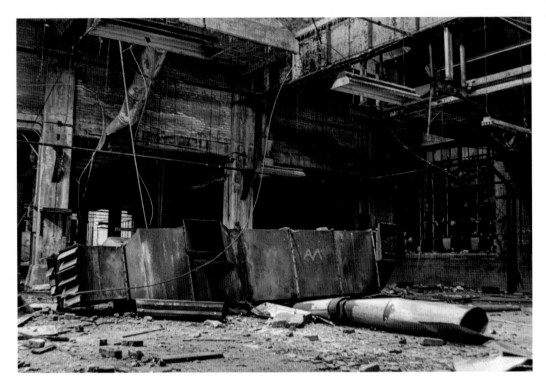

Ventilation. This unit that was part of the ventilation system had fallen. You can see where it used to be connected. I can only imagine the sound it made when it hit the ground.

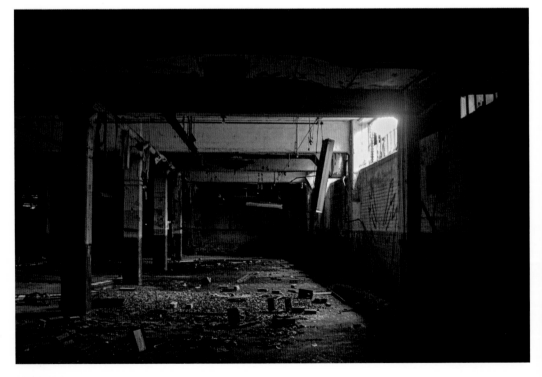

Untitled IV.

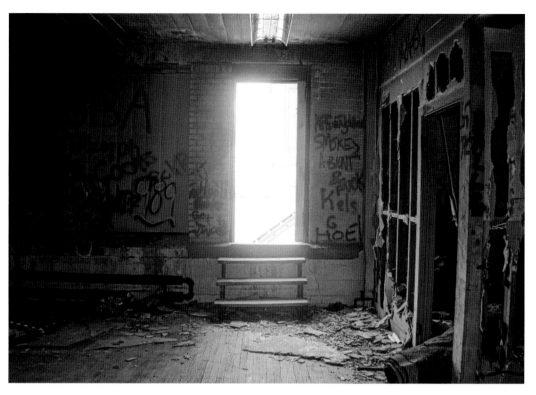

A Way Out III. This door leads to the roof, and again all of that light shining in is almost spiritual in nature.

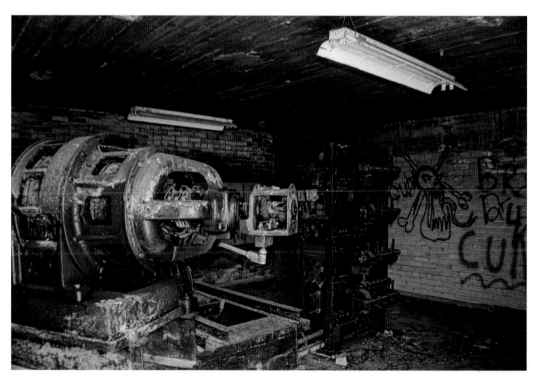

Freight Engine I. This is the motor for the freight elevator.

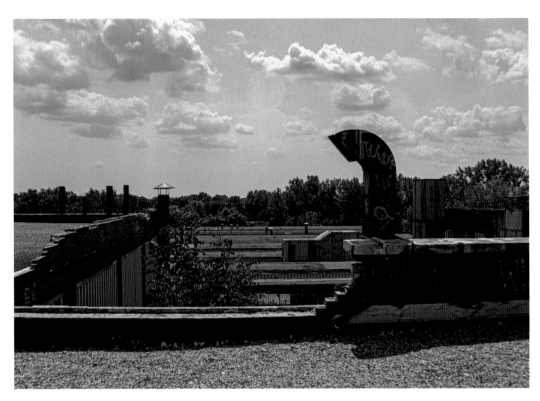

Rooftop I.

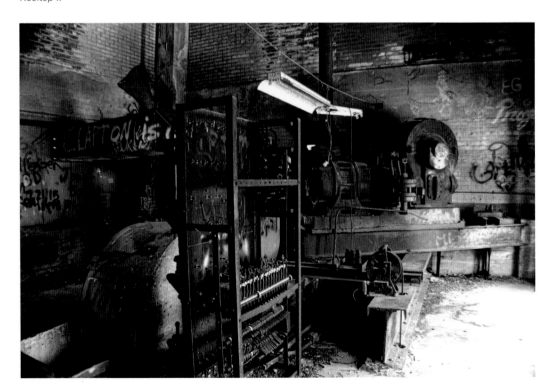

Freight Engine II. This is the motor for a second freight elevator.

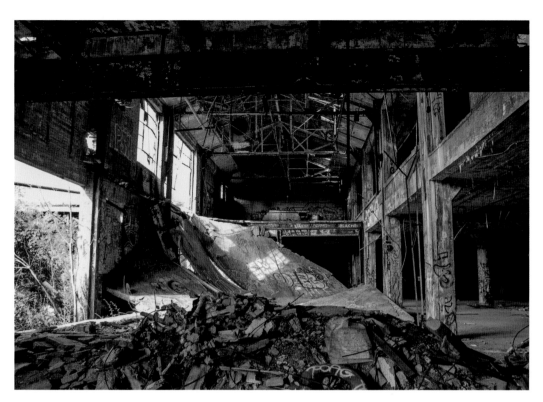

A Way Up. This collapsed piece of the second floor is the only way to get to the higher levels of Fisher Body Plant 21.

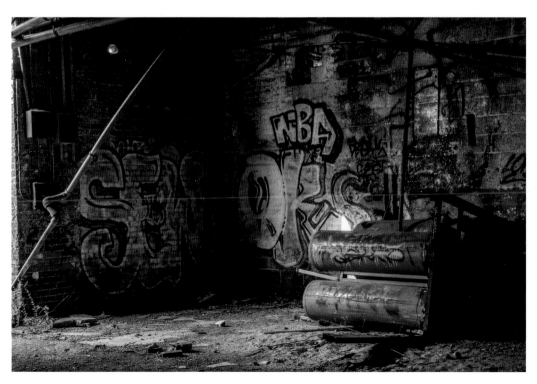

Untitled V.

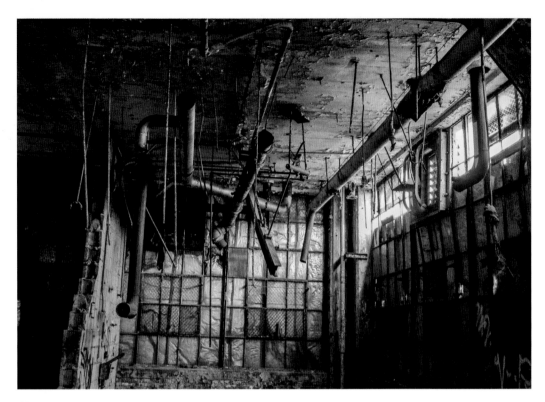

Pipes.

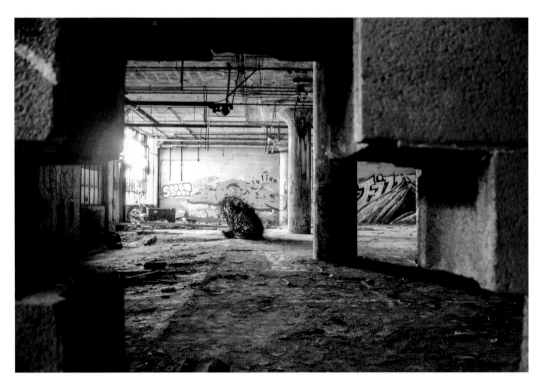

Peek-A-Boo II. The color here is awesome. That bush hanging out inside is a little weird though.

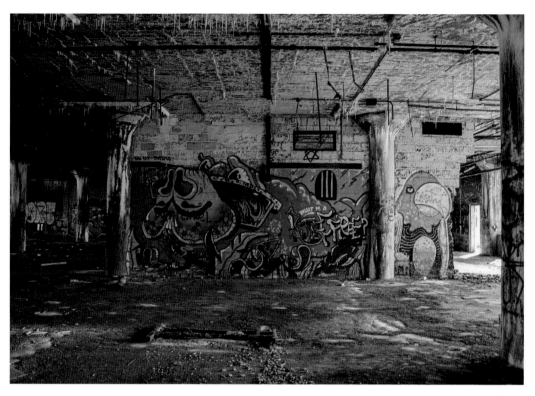

Art. This beautiful piece of work sits in a great spot as it's bathed in blue light from the windows to the right of it.

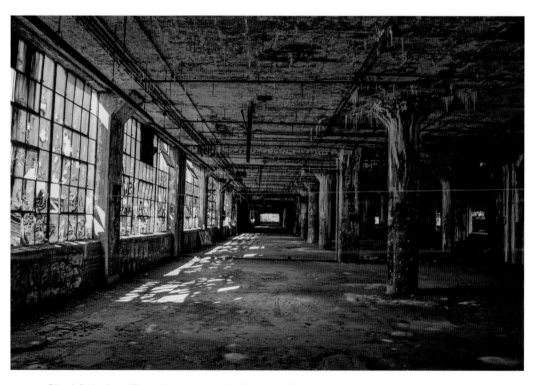

Blue. It feels almost like you're underwater in this section. It's such a nice change of pace from the normal lighting.

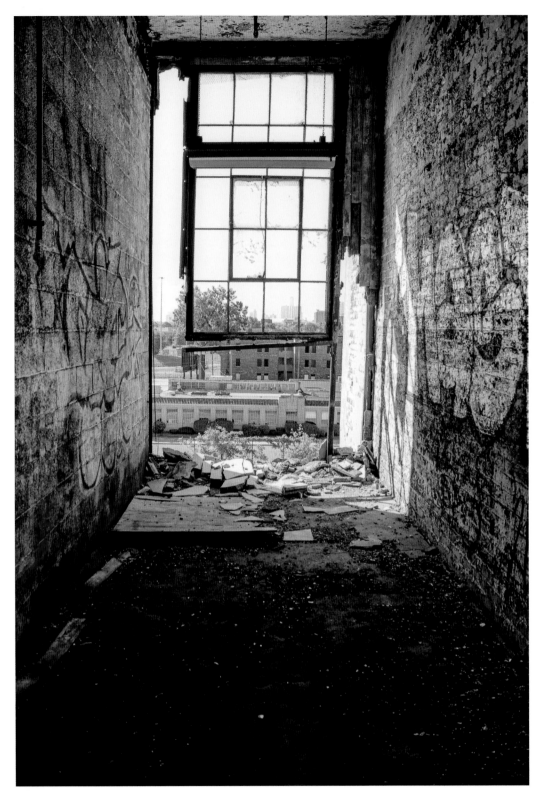

Window.

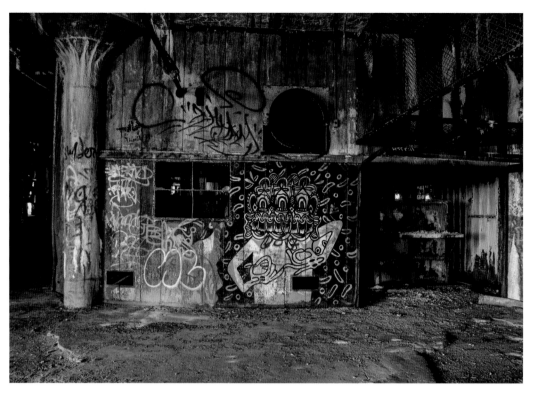

Art II. Another wonderful bit of color in the drabness of abandonment.

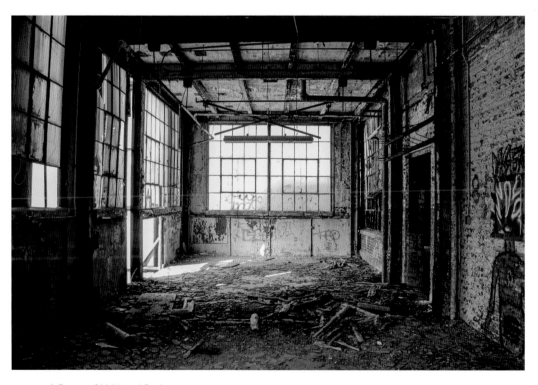

A Dance of Light and Dark.

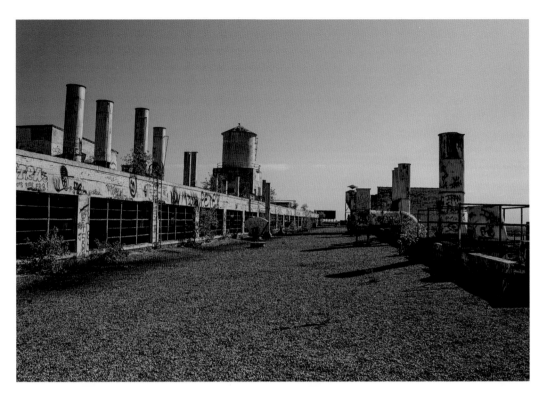

Rooftop II.

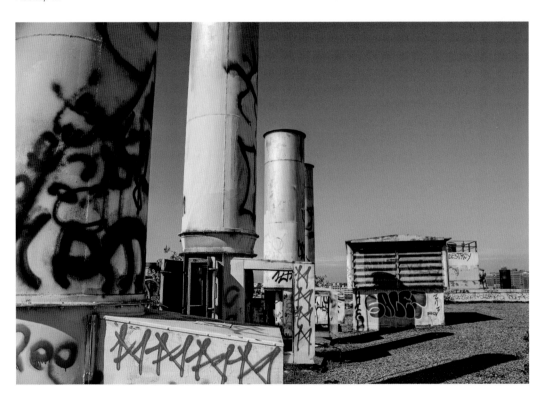

Rooftop III.

2

A HAUNTING TOURIST INDUSTRY

As I defined it earlier, industry can be considered any profit-making enterprise. A secondary result of the industrial heyday of Southern Michigan was a once-thriving tourism industry. Amusement parks and road-side attractions pepper the outskirts of major cities and along the highways that cross the state. Many of them rose up during the economic boom experienced post-World War II, and experienced the height of their popularity between the 1960s and the 1980s, only to slowly lose a customer base as the interest for hokey plaster and ceramic theme parks fizzled out in the 1990s, as well as the creation of larger main interstate highways that diverted traffic away from these locations. Many had to close up shop and have, for the most part, been left for nature to reclaim or for vandals to destroy. Most of these parks were family owned and operated and typically featured things like petting zoos, cheap looking plaster or fiberglass decorations, and a couple of carnival rides.

They cover a very wide area, with a surprising amount of them being in the middle of nowhere. A great example is the theme park known as Boblo Island which is on Bois Blanc Island between Detroit and Ontario. Another example near Detroit was the Belle Isle Zoo. As we move farther west, you'll arrive in Onsted, MI, where you'll find the biggest tourist trap in the middle of nowhere. Only a few miles from the Michigan International Speedway, this area used to be bustling, especially during race days. It now it sits as one of the strangest amalgamations of tourist traps. From the towers of the Irish Hills, the old Western themed inn, the "Mystery Gravity Hill," to the now-abandoned Prehistoric Forest, and just a couple miles away from that, an abandoned theme park with a waterslide, mini golf course, and go-kart tracks. It's every strange touristy thing you could ever want to experience all in one remote strip of highway in Southern Michigan.

The Prehistoric Forest, in particular, is very interesting: an overgrown series of forest trails peppered with the decapitated remains of fiberglass dinosaurs, a mountain of fiberglass standing proudly at the front gate for all to see, and an A-Frame building that's reminiscent of something from *Jurassic Park*. There's a great unease that lingers here. It was started in the 1960s and ran until the early 2000s. Some of the figures that survived were moved to a warehouse where they can be protected against vandals. To the north, in Saginaw, lies the old fairgrounds and racetrack. Starting the 1880s, this location operated as the fairgrounds and held auto races on a dirt track until they stopped around 2005. In the fourteen years since, the racetrack has become entirely overgrown to the point that you can only tell a racetrack was there from the plastic rails that guide its inside lane. The grandstand is impressive and monolithic among the field of overgrowth. Going north, just past Saginaw, in the town of Pinconning, MI, there sits a bright blue castle beside a pretty empty highway. This is the Deer Acres amusement park. At one point, it had multiple amusement rides, as well as a petting zoo and even some monkeys, all within a storybook fairytale theme. It's been through various owners and various states of openings, closings, renovations, and abandonment over the last ten years. This has resulted in not a lot happening and time slowly taking its toll on the fairytale structures and decorations, leaving behind an incredibly unsettling collection of plaques recounting fairytale rhymes painted onto rusting overgrown structures, and a bucketless Ferris wheel whose silent figure is very reminiscent of the Ferris wheel at Chernobyl.

These locations are probably more eerie to visit than factories or other industrial buildings, because there's something very uncomfortable about a place that children and their families used to visit in droves for fun and excitement being so dead. It's a strange juxtaposition to have the stillness of abandonment with the ghosts of excited laughter, shouting, and movement. Another thing that makes it unnerving is the cracking of the paint on the plaster cast decorations. Tin soldiers smiling away with their cracked faces. Prehistoric creatures, flaking away while being swallowed by foliage. It makes you think about the memories people made in these places—the days of fun families spent in these campy, silly, simple places on a summer day. It's also strangely upsetting to see these simple decorations destroyed, if for no other reason than it feels like one person's attempt to destroy the memories of others. However, many of these places are not completely forgotten, as there are plans to attempt to renovate them and reopen them as the same hokey tourist traps that they were back in the day, though it remains to be seen. Perhaps there's still a future for simpler times and simpler forms of entertainment.

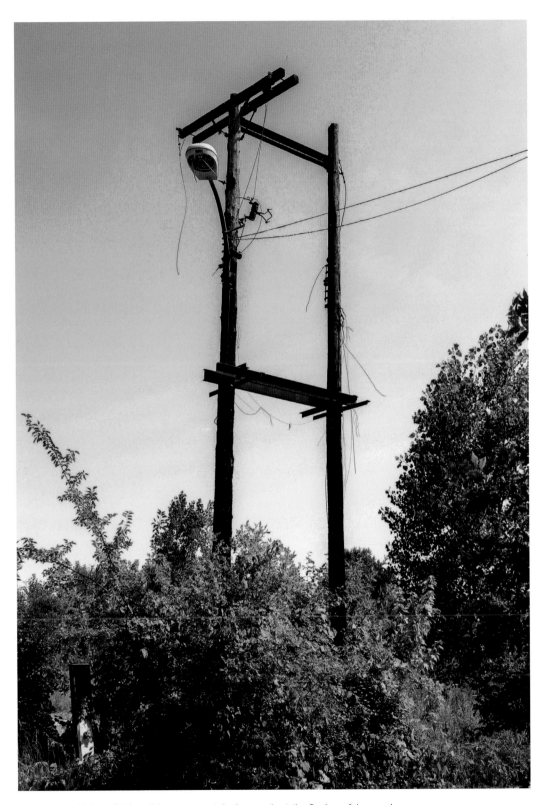

High Voltage II. I love this overgrown telephone pole at the Saginaw fairgrounds.

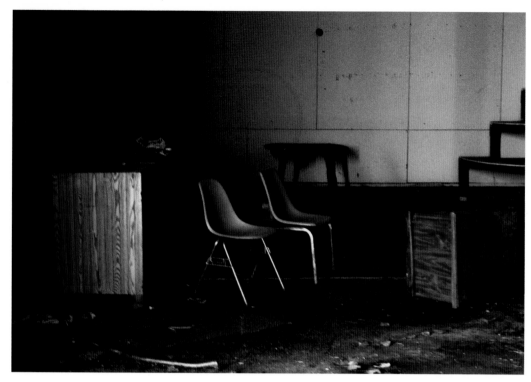

A Chair For You and Me.

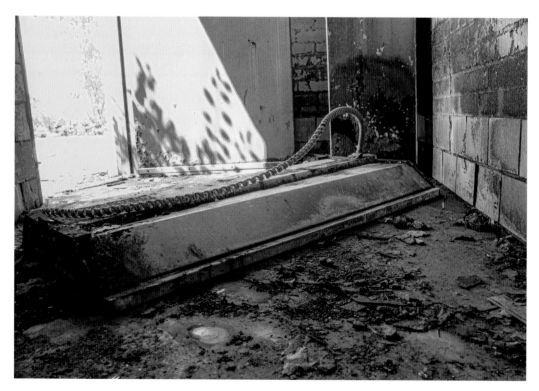

Decay II.

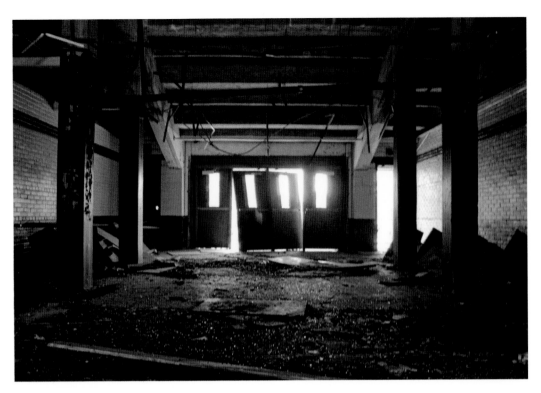

A Way Out IV.

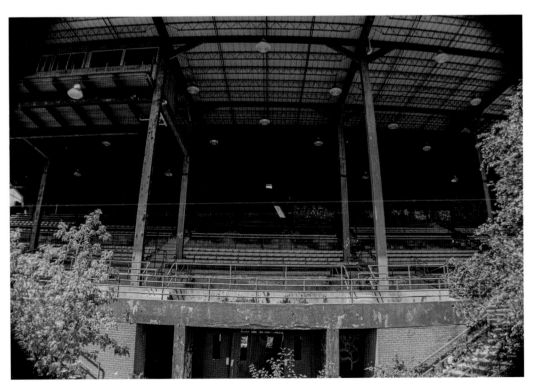

Grandstand I.

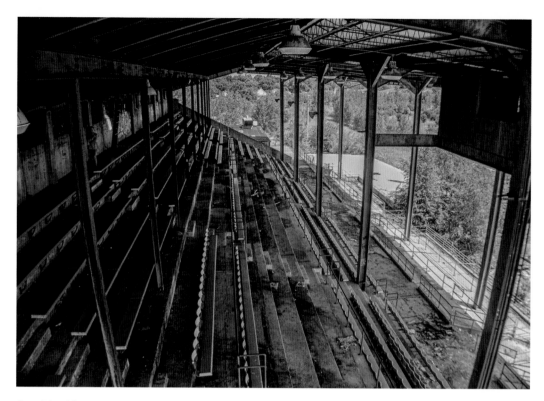

Grandstand II.

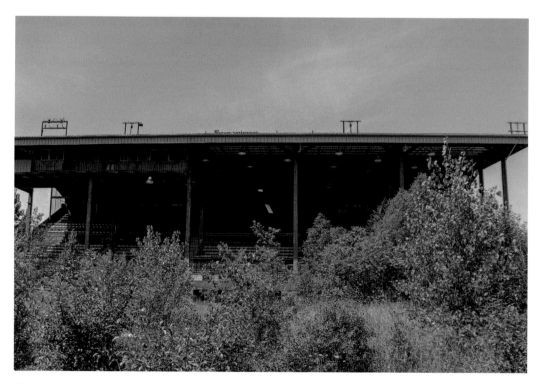

Grandstand III.

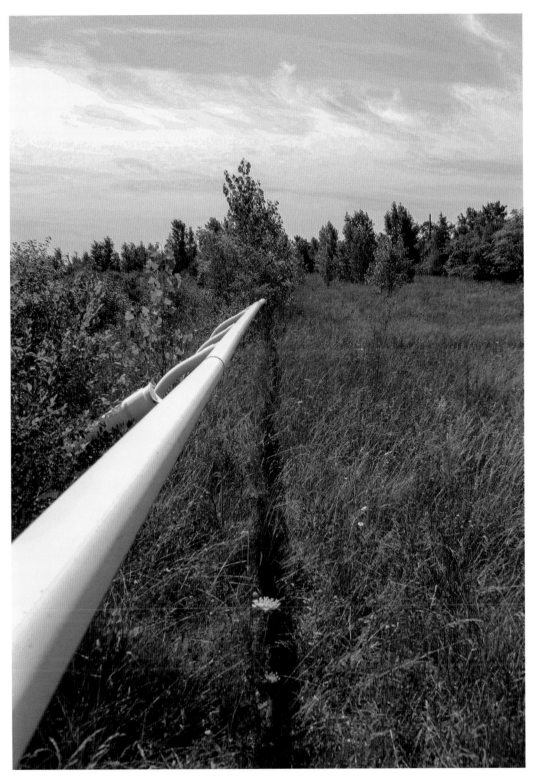

On The Track. You'd never guess there was a racetrack right under feet if you were just standing there. It's totally overgrown now, but used to hold auto races for almost 100 years.

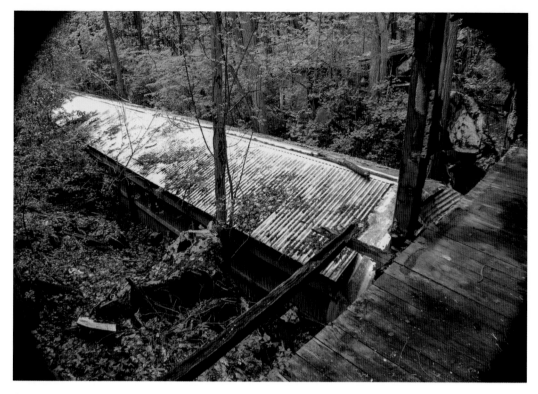

Corrugated.

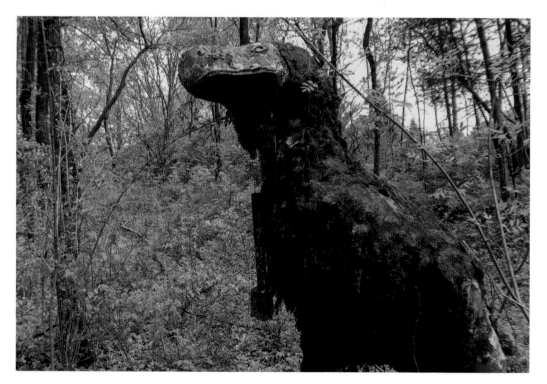

Dodo. This decaying dodo bird is in the abandoned Prehistoric Forest in Onsted, MI.

Decapitated Dino.

Peek-A-Boo III. This guy will surprise you if you aren't paying attention.

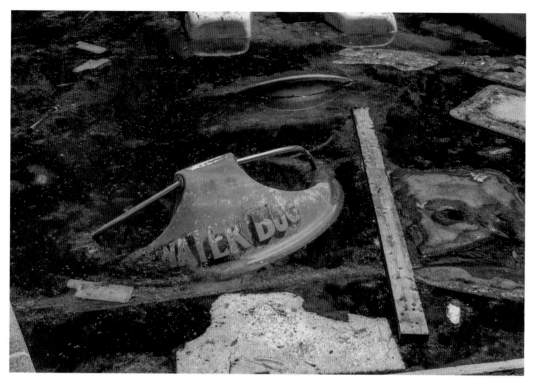

Irony. It says "Waterbug" while it's submerged in water.

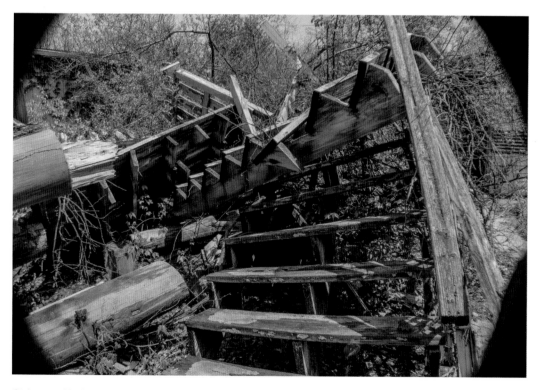

Stairway to Nowhere III. This used to lead up to a waterslide. Now both rest in pieces on the ground.

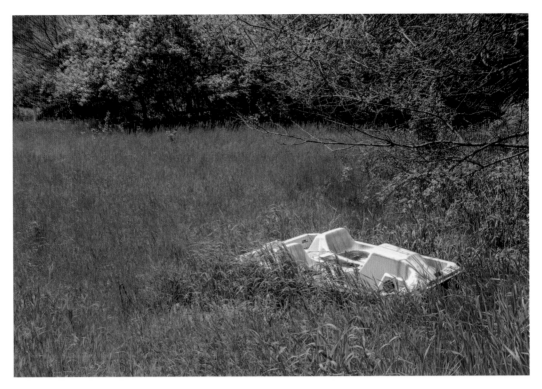

Irony II. That paddleboat won't get very far on land.

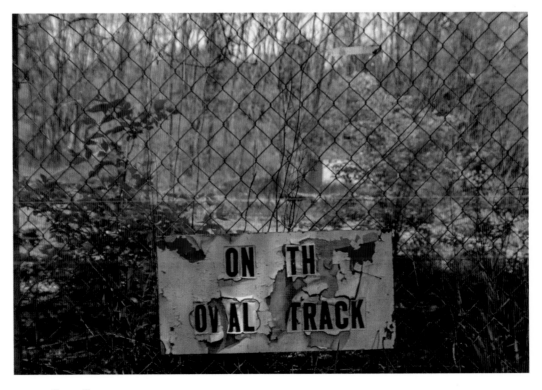

Decay III.

Overgrowth III. A go-kart track that has been widely reclaimed by plants coming from all directions.

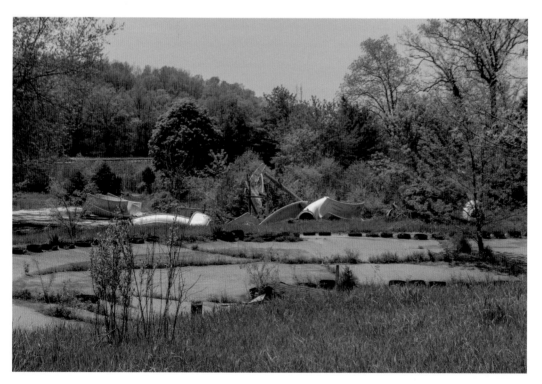

Decay IV.

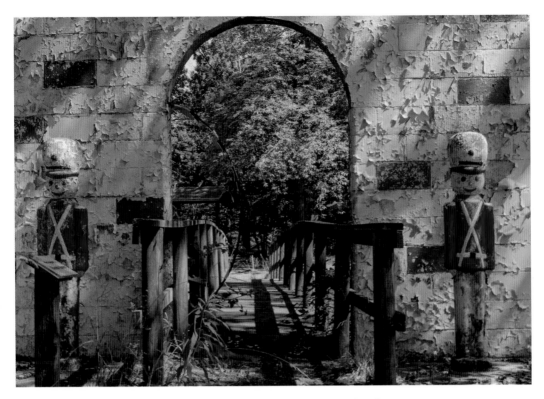

Tin Men. These tin soldiers guard the bridge behind Humpty Dumpty's wall.

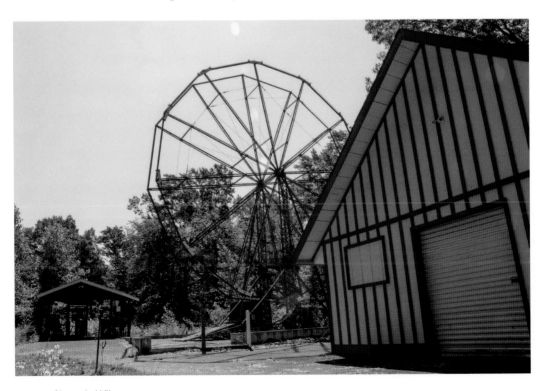

Chernobyl Vibes.

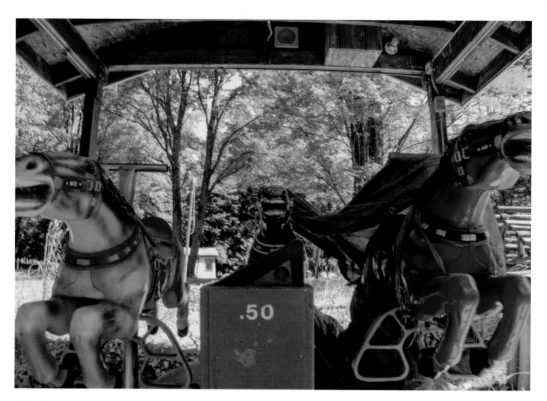

Off to The Races.

Decay V.

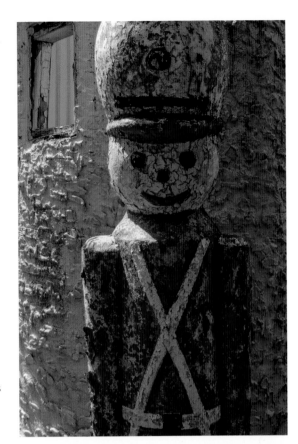

Right: Peel II. The cracking face of this tin soldier is incredibly eerie, especially with his never fading smile.

Below: Decay VI.

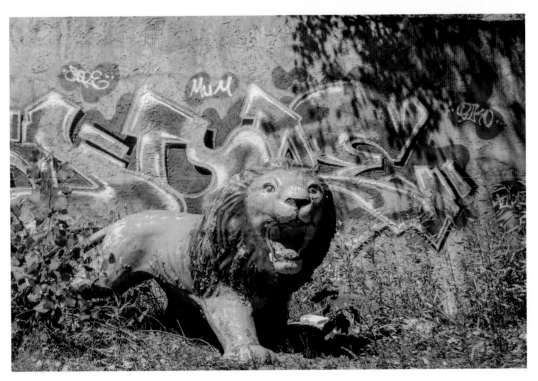

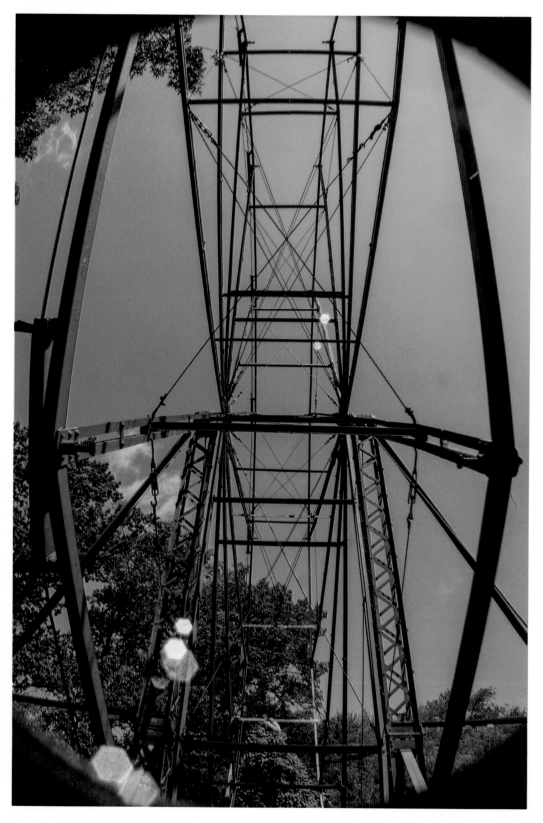

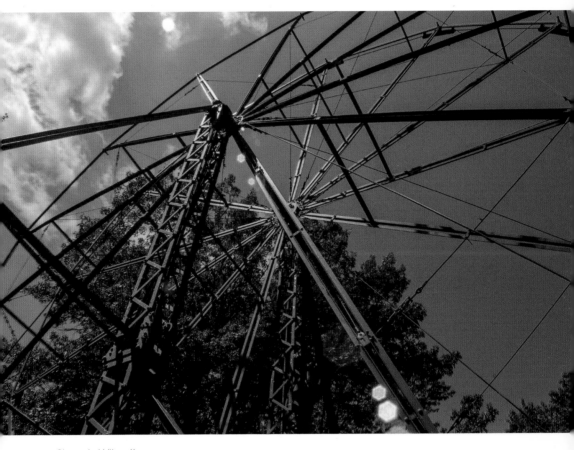

Chernobyl Vibes II.

Opposite: Untitled VI.

ABOUT THE AUTHOR

BRYCE RICKMAN has a degree in graphic design and works in a print shop near Ann Arbor, Michigan, He is a hobbyist and aspiring artist, poet, and musician. As a native of Southeast Michigan, he grew up in the shadow of the same monolithic ghosts of industry that he now seeks to photograph. Relatively new to urban exploration, he seeks to capture and convey through photography a sense of empathy and wonder for the places forgotten to and frozen in time. You can find more on Instagram: @relykphotography.